Philosophical Notes
An Outlook

Philosophical Notes
An Outlook

Adrian Brockless

Copyright 2009 Adrian Brockless

The Copyright of this work rests with the author. No quotation from it should be published in any format, including electronic and the Internet, without the author's prior written consent. All information derived from it must be acknowledged appropriately.

ISBN 978-1-4452-0931-9

For Victoria

ACKNOWLEDGEMENTS

There are many whom I need to thank, not just in terms of the preparation of this work, but those who have generally inspired me to reflect. I enjoyed a privileged upbringing – not monetarily, as many are so apt to think of privilege these days, but insofar as my parents showed me how life can be saturated with all sorts of wonderful things. As a child, I developed a love of the natural world and of the heavens, and was met with nothing but encouragement. I shared these loves in particular with my father who, in his own way, showed me through example, what they could mean to someone, and what a life could become through that love. A few of my early school teachers were less enthusiastic – one suggested that I should "renounce such esoteric subjects and concentrate on school work" (concentrating on school work was his wise advice). Another seemed worried by the fact that, as an eight year-old (and a chorister at St. Pauls Cathedral at the time) I found pleasure and great beauty in renaissance church choral music – though I was not really religious and remain that way now.

Since then, I have been fortunate with my friends and teachers, particularly at secondary school and university. I shall not mention my university teachers by name, since they may frown on my publishing these notes in the way I have. Of my school teachers I am indebted to Michael Rutland who was, by far, the most inspirational science teacher I ever saw – he evinced a love of, not only his subject (physics), but of what it could mean to love the sciences. My English teacher Barbara Wallard, whose love of literature and language

saturated her teaching, was similarly inspirational (though I think I probably infuriated her). At university I was extremely fortunate – all my teachers were very fine. There were two however, who were exceptional and illustrated (in their different ways) more than any others what it means to think about human life.

In addition, I would like to thank all those with whom I have talked about the topics in this book. Conversations with them yielded insightful comments and criticisms that have invariably made me think more, and nourished the content of what I've written. I am particularly grateful, in this respect, to Victoria Barnes, Michael Campbell, Catherine Muge, Tom Bashford, Eleanor Clayton, Derek Jones (for his comments on music), Stephen Hackett and Sarah Beckett.

Finally, I would like to thank my mother for proof-reading much of what I've written.

You may know a truth, but if it's at all complicated
you have to be an artist not to utter it as a lie.
(Iris Murdoch, *An Accidental Man*)

PREFACE

This book is not a typical philosophical text (I'm not sure that there should be such a thing); it is only really a series of notes – what one might call short philosophical reflections – on various subjects grouped, loosely, into topics. They are not argued and developed in a way that would draw praise from any academic wing of philosophy. Nevertheless, their content - particularly early on - is often closely related to problems that command the attention of that wing. On the whole, the themes and subjects dealt with largely reflect the conditions that I was encountering at the time of writing; the earlier notes, for example, are responses broadly concerned with thoughts and ideas present in academic philosophy, because at the time of writing, I was a part of an academic environment. Later on, their subject and character becomes largely concerned with questions which arise in various others ways of living. The questions and difficulties are still of a kind that demand philosophical reflection, and their subject matter is sometimes similar; yet the emphases, in terms of how such subjects are approached is, almost always, radically different (often subject to different kinds of scepticism, for instance). Consequently, the character of the philosophical reflections in response is very different. This, in itself, is instructive and revealing. It shows academic philosophy to be of a particular kind, defined, to a substantial extent, by the

academic way of life which determines the character of the problems it sees as important; what we think of as academic standards. It is a way of life that is, in a number of ways, significantly detached from more typical ways of living. For that reason, some outside academic institutions, are apt to criticise it as retreating into ivory towers and away from the "real world." They are not always unjustified in their criticism; some of the problems tackled in university philosophy departments do appear to be little more than problem solving for the sake of it. Nonetheless, ivory towers are fundamental to the perpetuation of individual independence of mind. As ivory towers, they partly shield academics and students alike (in any discipline) from the cultural pressures of their times, ensuring there is a space which allows ways of thinking to develop that are not in service to the culture of the times. It is an obligation for these institutions to provide such spaces, and is why they are often thought of as "not part of the real world". However, as progressively greater pressure is applied to schools and universities, mainly by politicians, to become "more relevant to the modern age," there is a danger that the protective bubble with which such institutions shield their students and academics, will burst. In many cases, this is already happening.

Nonetheless, I do not think that academic institutions – defined as they are by their (academic) practices – always provide the best conditions in which to practice philosophy (though I in no way wish to be thought of as condemning philosophy as it is practiced in academia). That is partly because of the kind of discipline philosophy is; it is a practice that does not (and should not) limit itself to particular ways of thinking, unlike other academic disciplines such as

theology, linguistics, physics, history, geography and so on. These latter disciplines are characterized and defined by their associated ways of thinking; that is what defines them as disciplines, and academia provides the best environment for their development. Academic philosophy is similarly defined by its adherence to definite methods; those practices are what distinguishes it as *academic,* but that immediately sets limits around the ways in which it is done, since it is answerable to academic standards. What I have done in this book is not of that kind and would not be satisfactory in academic circles.

II

So what exactly is philosophy? This is a question that is often answered opaquely, but it need not be so. It is frequently thought (quite naturally) that every discipline needs to have a subject matter of its own – mathematics, for instance, deals with numbers; history, with what has happened and its meaning; science has a broad subject matter which is generally specified by its sub-categories (physics, astronomy, biochemistry, geology etc.) and so on. Until the modern age, philosophy was, at least in part, concerned with the natural sciences. The philosopher was part astronomer and mathematician for instance, as well as someone who thought about moral questions; consider, as examples, Aristotle in the ancient world and Descartes in the early modern era. As a philosopher, one practiced all of these things – they were part of what it was to be a philosopher. Nowadays, of course, these disciplines are thought of as subjects in their own right, and philosophy has been left with the issues – often considered abstract issues – that are outside the scope

of many of them. I have encountered many outside academia who believe that philosophers sit around mulling over possible answers to abstract questions such as: if a tree falls in the forest and there is no one there to hear it, does it still make a sound? There is little truth in this belief, though it is (dubiously) alleged that the philosopher Bishop Berkeley originally posed the question. It is a question sometimes put to first year philosophy students to start them thinking critically and logically; and, of course, there are other questions of the same kind. Another conception of philosophy and of philosophers that I have encountered outside the academic environment is the belief that its concern is to wistfully consider the meaning of life. Few, if any, philosophers fit this bill.

That said, there is an enormous difference between wistfully pondering the meaning of life and considering the meaning that a life can have, or the dimensions of life that are meaningful - such as the arts, poetry, morality, war, justice and so on. These are complex aspects of our lives; they play particular roles in defining our conceptual apparatus providing us with the possibility for deeper understanding of ourselves and others, the relationships we have with justice, politics and so on. Frequently, disagreements and opinions are invoked as ammunition for or against other disagreements and opinions. This is what the philosopher concentrates on; he analyses complex thoughts and arguments, examines the ways we live with ourselves and others (including animals), invoking and examining the concepts we use to describe and criticise such relationships. Philosophers also look at how cultures work, what kinds of expressions they give rise to, how those expressions are understood within

and without a culture, and how that, for instance, influences what we find reasonable and unreasonable within it. They examine the methods of science and other disciplines, and provide perspectives from inside and outside conventional scientific practices; they look at how we acquire knowledge, what critical faculties we use to attain it and what counts as knowledge and justified true belief. They examine what it is (and means) to relate rightly or wrongly to beliefs – whether, for instance, a true belief has been arrived at through brainwashing or reasoned critical thought (and within that, examine what counts as brainwashing and why, and what counts as proper thought). They look at what it is and means to wrong someone, where our sense of right and wrong comes from – the critical concepts we use to determine and understand such things, and so on. This is by no means an exhaustive list.

Philosophy is, therefore, essentially a practice like any other, such as mathematics, history or science. We are all, to some degree, philosophers in the same way that we are all, to some degree, mathematicians. We use mathematics in our everyday existence – to calculate whether we can afford this or that, or to work out how much petrol we will use on a given journey – to a greater or lesser degree of sophistication; but we would not call ourselves mathematicians in the way those who are working on complex theories do. Similarly, we use philosophy in our everyday lives when we think about how we ought to respond to someone who has put us in a dilemma (such dilemmas often hinge on the meaning of what we may do, or have done and so on), or when we are critical of a piece of music or art work (wondering whether it represents things in an authentic way or whether it is banal or

nostalgic, for instance), or when we are assessing whether someone has received a just prison sentence, or when we are criticising (for good or ill) another culture and so on. There are many facets to all of these things – many complex arguments associated with them, some old, some new, and many different ways of assessing them. It is the complex dimensions of these arguments and ways of living that the philosopher is engaged with, trying to put them into some sort of perspective through making them lucid. The processes involved in this – the forms of thinking – are often difficult, as they rely so much on the thinking defined by their subject matter; absolute clarity is, therefore, often difficult to attain, but that does not mean we should give up trying to attain it, or that we should believe that it can only be achieved by the sciences. The difference between philosophy and other disciplines is not one of subject, but rather of practice; for whilst it is still a practice like any other, it is characterized by its lack of limitation in terms of subject matter. So it is, I believe, a mistake to think that philosophy should try to aim at producing results in the same way as virtually all other disciplines, and that is perhaps one of the most difficult things about it to grasp. Its aim, rather, should be to gain a clear view of (and expose) the causes – the bases – of paradox and confusion. That is why, despite numerous attempts, there are no proven or provable philosophical theories like there are in the sciences or mathematics, and is why there is no canon of philosophical knowledge. It is also, perhaps, why there is a degree of scepticism outside academia as to the usefulness or relevance of it as a discipline. Of course, in our general ways of speaking, we treat it as a subject like any other – consider, for instance, a person saying that they are going to university to study philosophy; linguistically,

it sounds very similar to, "I'm going to university to study geology" for instance – and in a way it is, insofar as it is a discipline that one can study in an academic institution. Thus, in one way, it becomes intuitive to treat it as a subject in the same way. It is in such ways however, that language can create confusions and it is the job of philosophy to expose how that happens and provide a clear view of why we find such things problematic.

III

The word philosophy translates from the Greek as "love of wisdom" (philo = love, sophia = wisdom). In today's cultural climate, this seems to be oddly confusing. People are apt to be suspicious of someone who, when asked what they do, responds that they are a philosopher and, when pushed to clarify further, replies that philosophy translates from the Greek as a love of wisdom. Many of our endeavours after all, it could be argued, are pursued in a quest for greater understanding or better judgement, and philosophy – because it has no subject of its own and does not yield definite results is sometimes thought of as "a bit of a cop out." How can it be as rigorous as other disciplines if it does not yield tangible results like they do? But that is to forget the *kind* of practice that philosophy is; and, of course, until the modern era, those engaged in the natural sciences and mathematics were thought of as philosophers. It is also odd because, by thinking that philosophy is "a bit of a cop out" one is implying that wisdom is easy to come by (or that wisdom is not something we should be unduly concerned about).

A few years ago, the (now former) education minister Bill Rammell suggested that it was "no bad

thing" if students dropped what he termed "non-vocational" courses such as fine art, philosophy and history, and pursued "subjects they think are more vocationally beneficial." Rammell's use of the word "vocational" is curious and is related to his conception of education.[1] He seems not to understand the difference between a profession and a vocation and, as such, fails to see what an education can give to a life beyond the acquisition of a good job; a "graduate" job. I am not exactly sure what Rammell meant by "vocationally beneficial" but it seems, from reading what he said, to amount to preparation that is beneficial for particular professions or the 'jobs market'; he is certainly not of the opinion that education for its own sake is as valuable. Perhaps he doesn't see the point of it? In any event, Rammell's conception of education is nourished by the idea of it as an investment towards a better paid career. That view cannot be compatible with the idea that education for its own sake nourishes a life in a way that nothing else can, because education for its own sake, by definition, cannot be geared towards certain ends.

Following the philosopher Raimond Gaita I talk extensively about the differences between a profession and a vocation. For the time being however, it suffices to say that a profession can be given away at anytime, but a true vocation is something that is a part of who one is as a person. A profession is only accidentally connected to a particular person, which is not to say that professional standards cannot be excellent.

[1] The modern use of vocation or "vocational qualification" merely suggests something non-academic rather than something fundamental to one's life and individuality.

Nevertheless such standards are not nourished by the kinds of obligations that are revealed by (and define) a vocation. Of course, lines between the two are often blurred since, from the outside, some professions and vocations can look much the same. A teacher or doctor, for instance, can uphold the highest professional standards but need never think about what they are doing in any other way than as their work. Conversely, a doctor or teacher, answerable to what they do as a vocation, will understand their work in the light of what it can mean; they will be nourished by what it means to bestow on someone a love of learning, or what it means to be able to heal. The spirit of what nourishes their standards will be very different from the spirit of what nourishes professional standards, despite the results of their work frequently being largely similar.

IV

Throughout, I have tried to be sincere; I have never gone looking for problems to solve or write about. My reasons for examining the problems that I do, arise from personal reactions to claims and disputes that I encounter; I have tried, nonetheless, to treat my own views critically. What I have written does not do the work of a conventional academic text and should not be expected to do so. Nevertheless, I think it represents one of the many non-academic ways of doing philosophy with all the positives and negatives that that entails. I have already said that I do not wish to be understood as criticising academic philosophy; my suggestion is only that, because of its nature as a discipline, it should not be considered the only way.

The notes are in numbered paragraphs chiefly because I want them to be treated individually, though

not in isolation – they are no more than a psychological device designed for that purpose. Where there is an obvious continuation of ideas or arguments – that is, where one paragraph relies heavily on the previous one for its full meaning or significance – I have put an arrow between them. There are many cases where I do not put arrows, but that does not mean there is no relationship between two paragraphs; indeed, in a good number of cases, neighbouring paragraphs contain the development of previous remarks in some way or other. Other than the loose grouping together of paragraphs according to topic, the structure of the book is generally determined by the development of my thoughts, rather than being a *fait accompli*; occasionally (particularly early on) I have included paragraphs that I later contradict. Throughout, I develop and re-examine themes and ideas from different parts of the book; ideas in the latter half of the book are, by and large, much more sophisticated than those at the start. I have chosen the subtitle "*an outlook*" because it is from a particular way of doing philosophy that my comments arise and are developed.

I have tried to be lucid, though I have not simplified any of the philosophy in order to make it easy to understand. Some of the ideas and arguments are difficult, and time should be taken when reading them; all philosophy should be read more than once. There are various ways of viewing what I have written but, because I have not argued for them as one would in an academic text, I would like the reader to temporarily put his own views aside and take the time to make sense of how I have expressed myself here; I also hope you will use imagination. That said, because they are notes, they do not require the same continuous sustained effort to read

as an academic text; to a point at least, one can dip in and out of them at any place in the text. The book is not scholastic in any way, though as you will note from the bibliography, I have been influenced by a number of writers – most heavily by Ludwig Wittgenstein, Rush Rhees and Raimond Gaita; anything of merit I have written I owe to their work; faults are entirely my own.

Life is saturated in all its forms with wonderful and terrible possibilities - with joy and suffering, love and hatred, justice and injustice - many driven and nourished by our own points of view and perspectives. The spirit in which one lives can determine our joy and suffering, as much as what happens to us; for it is the spirit in which one lives that casts the world in a certain light and – through that – shapes meaning. That is why I believe philosophy to be so important and I hope the spirit of that is reflected in what I've written.

INDEX OF THEMES

This index is only intended as a guide. It lists paragraphs, or groups of paragraphs, where a theme – such as education or art – is discussed in the most detail; it does not list every instance of where a particular topic is mentioned or the context in which it occurs, and is only intended as a guide.

Paragraphs 1 – 11 inc.: Facts, propositions & moral thinking; rational deliberation (marriage, national pride and shame); guilt.

Paragraphs 12 – 17: rationality and trust

Paragraphs 18: religious life

Paragraphs 19 – 28: individuality; ethics and principles; loss of a relationship and sentimentality; grieving for a pet.

Paragraph 29: Education

Paragraphs 30 – 32: philosophy and literary examples.

Paragraph 33: forms of the grotesque ; the killing of animals; murder.

Paragraphs 34 – 54: short comments on survival of the fittest, reason and reasons; suicide; conceptual content; necessity; independent reality.

Paragraph 55: Compassion.

Paragraphs 56 – 61: attitude and psychology; individuality and absolute standards; cognitive and non-cognitive content; psychology; masculinity and

femininity; general facts and relationship to judgement; necessary connections and forms of life.

Paragraphs 62 – 65: realm of meaning; concepts and understanding;.

Paragraphs 66 – 67: artificial intelligence and individuality.

Paragraphs 69 – 74: ways of living including comment on exploitation of ambiguity and relationship to rationality, forms of expression and understanding, rape and love. Comment on Bernard Williams's lorry driver example.

Paragraphs 75 – 76: poetry and understanding – its relationship to ways of living.

Paragraph 77: comment on McDowell

Paragraphs 78 – 95: various short comments on bodily expressions/behaviour, relationship to conceptual content and epistemology (including rational justification).

Paragraph 97: Comment on western academic philosophy.

Paragraphs 98 – 99: behaviour - consciousness and epistemology.

Paragraphs 100 – 101: moral explanation.

Paragraphs 102 – 103: Darwin and evolution; Love.

Paragraphs 104: Language and practice.

Paragraphs 105 – 106: moral obligation and conflict; individuality informed by grief, love and pity.

Paragraphs 107 – 110: Language and ways of living; art.

Paragraphs 111 – 117: Sergiu Celibidache and music.

Paragraphs 118 – 119: music; psychology and understanding.

Paragraphs 120 – 124: psychology and individuality; narrative understanding (form and content).

Paragraphs 125 – 133: what counts as reasonable argument (thinkable and unthinkable); meaning, consciousness and perspective; compassion and pity as informing dimensions of understanding (of thinkable and unthinkable); expressiveness and understanding. (Wittgenstein/Gaita).

Paragraphs 134 – 135: freedom; education.

Paragraphs 136 – 142: natural history, meaning and understanding; individuality and rights (Jamie Mizen); language of rights.

Paragraphs 143 – 144: authority of rights.

Paragraphs 145 – 146: language – meaning and definition.

Paragraph 147: concepts, practice and logic.

Paragraph 148: rights and moral behaviour.

Paragraph 149: dignity and love.

Paragraphs 151 – 158: how we use language.

Paragraphs 159 – 172: sanity, madness; conceptual content; Wittgenstein's private language argument; meaning and moral relativism.

Paragraphs 173 – 181: psychological and moral impossibility; meaning and the spirit in which

something is done (Simone Weil); culture and moral practice; the morally pure life.

Paragraphs 182 – 184: cultural relativism.

Paragraphs 185 – 189: consistency and inconsistency in response and relationship to different ways of living; the authority to speak and political correctness.

Paragraphs 190 – 207: detailed discussion of what counts in argument (and what counts as proper argument), standardization, judgement, common sense.

Paragraph 208: humour and its relationship to understanding.

Paragraph 209: Spirit and meaning.

Paragraphs 210 – 220: general facts and standardization; education and standardization; good judgement and common sense; spirit and meaning; culture and what is thinkable and unthinkable within it.

Paragraphs 221 – 222: education and training (what nourishes the conceptual difference).

Paragraphs 223 – 229: thoughtless scientism and what it leads to; what should and should not be free from questioning in a quest for rationality.

Paragraphs 230 – 232: tying the unthinkable to logic; behavioural models.

Paragraphs 233 – 239: is chivalry sexist?; masculinity and femininity.

Paragraphs 240 – 242: social inclusion/kindness; poetry and ways of living; relationship of language to practice.

Paragraphs 243 – 245: character of argument (including critique of academic intellectual argument); consequentialism.

Paragraph 246: paranoia and false belief; experience and what we learn from it.

Paragraphs 247: Time

Paragraph 248: Knowledge of different cultures and their practices.

Paragraphs 249 – 277: teaching and education (Anglo-American culture); profession and vocation; education for its own sake; authentic conversation; education and its relationship to how we separate cognitive from non-cognitive content; life lived in a spirit of gratitude; preferences, interests and their meaning.

Paragraphs 278 – 280: language analogies and their relationships with our practices; confusions caused by misleading analogies; preferences, interests and their meaning.

Paragraphs 281 – 282: logic and language.

Paragraphs 283 – 290: art and forms of thought; education; art and film (music and film); art and its relationship with conceptual content.

Paragraphs 291 – 305: art, culture and education; forms of thought giving rise to artistic expression; ways of living and art; art as meaningful expression; ethical awareness, culture and art; art nourshing understanding.

Paragraphs 308 – 309: gratitude; preferences, interests and their meaning; understanding that takes time to achieve.

Paragraph 310 – 315: Seeing and being aware of; taking time and how this conditions conceptual content.

1. Are there deep facts? Why, for instance, if (moral) thought is only propositional would moral depth consist simply in knowing many facts? Can't there be deep facts, knowledge of which is itself therefore deep? The first thing to do is to examine the nature of language and what it means to be rational: a fact is a proposition – for example, "the tree to the left of the post box is in leaf!" There are true and false propositions and one might think something to be a fact and then discover the proposition is false: "The tree to the left of the post box is not in leaf after all!" Thus sensible propositions operate on grounds of truth and falsity, with modes of valid and invalid inference in between. If the whole of language operated in this way then meaning would never rely on context, insofar as grammatical form would negate the possibility of an expression meaning different things in different contexts. Consider Wittgenstein PI:21 and his discussion of an expression that is in the form of a question, but is really a command.

↓

2. In terms of depth and speaking sensibly of it in a language that consisted entirely of propositions, it (depth) would have to possess a series of necessary and sufficient conditions in order to make propositions about it sensible. It follows therefore, that for depth to possess necessary and sufficient conditions, it must itself be made of a series of propositions; we should have to verify that a man is deep by appealing to such

propositions. (Everything truth-valued against everything else.)

↓

3. So can we consider moral thought as propositionally based? If moral thought is just propositional in form, then it is difficult to see how there is room (even) for the concept of depth. For the significance of one's moral decisions would be valued (in terms of significance) in the same way as decisions such as that to get a new car, - i.e. only contingently attached to the person making it. In other words, such decisions can either be correct in terms of resulting in exactly what I expected, or they can be (at the very least) correct in terms of procedure, even if subsequently, the result of the decision was not what I had hoped for or expected. One can be incorrect in terms of one's expectations, but remain correct in terms of procedure. Certainly, in terms of my expectations, the correctness of my decisions is contingent upon external conditions. So this now makes it look as though depth is merely a matter of procedure. Providing I am correct in terms of my procedure then I can be said to have depth; presumably this means that the author of Sony's latest mini disc instruction pamphlet is a man or woman of depth? Knowledge of many facts can then be said to be the sole ingredient of depth, insofar as it is what goes to inform us in terms of correct and incorrect procedure.

↓

4. This results in there being only one kind of deliberation in all things. I am procedurally

correct to insure my house if there is a 33% chance that it will burn down. Similarly, I am procedurally correct to insure my marriage if there is a 33 % chance of it failing. – But does this not directly contradict what it means to marry? Procedurally speaking, it is literally nonsense to say that I marry (meaning "for as long as we both shall live") and at the same time insure it against possible failure. Thus, a contrast can be drawn between deliberation in terms of house insurance, and deliberation in terms of love (marriage). There are two distinct forms of understanding here.

↓

5. In this 'one kind of deliberation' my individuality is of no consequence – anyone with the requisite cognitive capacities can eventually arrive at the correct procedural path to take by discovering the relevant facts; none of the procedures actually changes me as a person, i.e. cannot change my perspective. The decisions that weighed with me *then*, weigh with me in exactly the same way *now*. The only difference being that external conditions may have changed.

6. Thus we can see that suggesting that there is only one form of deliberation results in a kind of nonsense. - But assuming moral deliberation to be of a special kind, a kind in which moral concepts are appreciated to be non-externally justifiable (such as love), can we talk of the existence of deep facts? If we appreciate the existence of the

concept of a person with depth, can we not say that there are certain facts that are deep?

↓

7. We can see the contrast between the deliberation of a third party and the individuals involved, if we return to the concept of marriage. The third party will say that it makes sense to take out a prenuptial agreement, as there is approximately a 33 % chance of the marriage failing. However, those getting married (assuming there are no exceptional circumstances such as marrying to get a passport etc. or marrying for money) at the time they marry, believe it to be forever (not *possibly* forever). The concept of love is necessarily transparent (that's what allows us to understand it as a concept), but within such a concept is the possibility of privacy that allows recognition of two people being in love, without direct relation (access) to that love – i.e. we cannot experience X's love for Y in the way that X experiences it. We can say similar things about what it means to be wise. Wisdom is essentially seen to be something which is shown through how one copes with concepts such as love - perhaps wrestling with love, cynicism, sentimentality and so on. Finally, wisdom can only be shown up by example - that is to say, shown up by examples of what it is not. As such, the wise man is someone who shows understanding of such things; an understanding that is made manifest through a way of living - not through actions dotted here and there in their existence, that are only wise, as it were, by coincidence. Certainly, we can see that it

is possible to speak of somebody as deep and assert propositions to that effect.[2] One can say that "X is wise" - and this is in the form of a proposition; for those who recognise the possibility of wise individuals, such a proposition could be seen as a fact. Nevertheless, one cannot say of "X is wise" that it, in itself, is deep. – And an individual who is wise could say nothing in propositional terms about his experiences that would allow those propositions to be seen as deep in their own right; for wisdom itself cannot be broken down into such propositions without dragging its constitutive concepts into the abstract. To do that is to remove the forms of life in which one is able to distinguish the wise from the foolish. In other words, a foolish man could, accidentally, perform an action that could be construed as wise if performed by a wise man, but in this case it's more likely to be a coincidence or luck; if a wise man had acted in the same way one would probably have said the action was wise. It is our understanding of different ways of living that provides the conceptual apparatus through which we can distinguish between a foolish man doing a wise thing by coincidence and a wise man uncharacteristically doing a foolish thing. Our sense of surprise in each respect is partly internal to our understanding of wisdom and foolishness.

8. Guilt is a peculiarly individual phenomenon – that is, everyone has the capacity for guilt, but it is not something that can be authentically shared except in a false, consoling way. Guilt is, in part, a

[2] Wisdom is a way of life that can only be achieved over time

recognition of what one has become after committing an immoral act – such recognition is a manifestation of an understanding of the violation of another's humanity and cannot ever be properly relieved in fellowship – even in the company of those who have committed similar acts (Nazi death-camp guards, for instance).

↓

9. But what about guilt felt by modern Germans? Surely that is collective? This, I don't think, can be characterized as guilt – rather shame. Such shame can be perceived by observing how willing a government of the people (an elected government) is to acknowledge its part in human atrocities. Such acknowledgement can take the form of compensation and legal judgments. In this respect a genuine consoling fellowship is possible and can accept, as proper (i.e., as an expression of shame), an individual's support for his government. In the case of the holocaust, it might take the form of support for the reimbursement of what was taken from Jewish families under the Nazis, as an acknowledgement of the evil committed.

10. Why is a genuine and consoling fellowship possible within a nation? The answer lies in the notion of national identity and the possibility of national pride. Pride and shame, in part, make community possible; if one has a sense of belonging to a community or nation, then within that exists the possibility of pride in that community's or nation's achievements. Pride however, cannot exist

coherently without the possibility of shame. Guilt is a very particular concept and is a manifestation of coming to an understanding of one's violation of another's humanity and also, in that respect, what one has become as a consequence. The grandsons of those who were responsible for a country's misdemeanours share their grandfathers' sense of national identity. Indeed, it is such historical influence that conditions a sense of national identity (a sort of "we who have travelled together"). The grandfathers provide their grandsons with a sense of heritage which is necessary for a properly conditioned sense of national identity. Thus, grandsons can be ashamed of their fathers' and grandfathers' actions, perhaps feeling a certain amount of associated guilt. - But that is not to say that such guilt should persist for ever – it should last no longer than three generations or so; for once more than three generations have passed the acuteness of wrongs done begins to wane, as there is no longer any direct personal contact with those who committed such atrocities. One can and should, nevertheless, still acknowledge the wrongs committed, but it would make no sense (for instance) for me to feel actively guilty (in the way I might feel guilty over the betrayal of a lover) for my country's actions of 200 years ago. That does not rule out a sense of national shame.

11. Certainly one can have knowledge that is deep. One can say: "that man has great knowledge of the world!" That need not mean that such an individual just knows a great many facts – one is asserting something else in the same way as one

does when we say that a teenager is streetwise. This is not knowledge that is epistemically conditioned by propositions or facts. It is knowledge achieved through ways of living that culminate in an historically achieved biography. Unlike factual knowledge, the knowledge I am speaking of here can never, potentially, be grasped instantaneously.

12. When one is called upon to be rational, what does this mean? It is essentially a call to sober reasoning; the presupposition by one individual that another has an ability to reason, and a call for him to exercise it. It is a presupposition of the human condition that we all have the ability to be rational (unless an individual has some kind of mental illness). This presupposition manifests itself in the diagnosis of mental illness in those who are unable to be rational. But what is the nature of rationality? If it is a call to reason, then to answer this question one needs to exercise what it means to reason in different idioms (such as moral or scientific). – But is there a difference in the kind of reasoning one employs in, say, the moral realm as opposed to the scientific one? In other words, if we rationally deliberate, then we reason. But is rational moral deliberation different in character from scientific deliberation? The answer to that question, in part, reveals the nature of rationality. If it is different then it must be answerable to a distinct kind of understanding.

↓

13. We can now talk about rational deliberation, and thus rational deliberation within argument. Are there aspects of rationality that demand trust?

↓

14. If there are aspects of rationality that demand trust, what are their epistemic conditions? Rationality in probability can be granted immediately; provided one possesses the necessary cognitive capacities to understand odds etc., one can be procedurally correct in terms of evaluating the likelihood of a particular thing or event occurring, and can only be said to be irrational if one maintains a belief that is wholly at odds with the evidence. Of course, one has to trust the sources upon which one makes rational judgments to be accurate, but this is a different case. I am, for my purposes, assuming that such sources are accurate.[3]

↓

15. Probability has the implication that one can still be wrong having rationally evaluated; that is the nature of probability (unless there is a probability of 1). In this respect, rationality consists of a formal kind of reasoning that can be applied with equal effect by human being and computer alike.

↓

[3] In any case, even if one's sources were inaccurate, that would not affect one's ability to rationally evaluate them. One would just end up with a wrong answer (but a justifiable one).

16. So where does rationality demand trust? When it is epistemically conditioned by experience. By that I am not speaking in terms of induction or probability, I am speaking of the role one's individuality has in shaping the decisions that one makes, and their significance; I am speaking of those decisions that one makes, that carry with them obligations - for example to get married - and that continue to shape our individuality. A decision to get married, for instance, is significant for me in a way it cannot be for anyone else. The point here is that, sometimes – depending on the situation – the individuality of a person can make the difference to what is rational for that person, insofar as the momentous decisions that he makes change the person making them and thus affect the possibilities for him in the taking of later momentous decisions.

↓

17. Ultimately the level of trust that is necessary for rationality is determined by the language game in which one is operating. In order for there to be intelligence and intelligent remarks, the possibility of their opposite must also exist; the same can be said for rationality. What shows up intelligence? Finally, only that which is not intelligence, and there is no benchmark for it, which means that ideas about it can change. Similarly, cynicism, compassion, pity, hatred and so on can only be shown up by example (within the conceptual framework through which we understand such examples).

18. One does not, I think, need to believe in a deity, or to follow religious teachings in order to be religious (though believing and following such things does not exclude that possibility). Living religiously, I think, involves being faithful to oneself - as to what one has dedicated one's life to. Yet that is not to say that anything can be a religion – it will be difficult, for instance, to accept someone claiming that their religion was achieving political notoriety or making money. One might say, in an attempt to achieve their aims, that they acted religiously according to certain ideas that they believed would bring them success. It is however (following Raimond Gaita), hard to imagine this person saying, "my desires may be shallow, I am a highly materialistic money-hungry person with no regard for any kind of spiritualism (unless it can increase my financial wealth) but, there it is, that's my religion." If a person says, "surely that's like any other religion really?" one can say that they have not properly understood the character of religion. But of course, in one sense, their point is not unreasonable: the person who aspires to political success and money acts according to those things which he deems will bring him that success. What is the difference between that, and acting in a way which, for example, brings deepened moral understanding or nourishes a spiritual dimension to one's life? But that is not how we use the word religious – it makes no sense to describe all aspiring politicians or financiers as religious people even if they act unerringly in accordance with the things that they believe will bring them

success, in the same way as, say, a monk acts in accordance with certain teachings (thus living in a particular fashion) that bring him closer to God. The concept of the religious is located elsewhere, for although the behaviour may be – at least via analogy – the same as the aspiring politician or financier, the religious life contains within it the requirement that we deepen understanding of what it means to think, and do, certain things; it wants us to understand what we do, not just in our heads, but in our hearts also. It is like saying that we understand the concept of love just from watching peoples' behaviour rather than possessing an awareness of the role that certain kinds of relationships play in our lives.

19. Part of humanity is individuality, and morality is the product of humanity. Therefore it would seem strange for morality not to be based on the particularity of all individuals. If it was not based on such particularity, we could not say that individuality (however construed) is a necessary aspect of humanity and how we understand it. Moreover, this would negate the importance of the emphasis that we place on such individuality.

20. If one tries to take out the individuality from ethics, one is essentially making the same mistake as the man who said that one could never step into the same river twice, or the man who questions whether a person at age 40 is the same person he was at age four, since virtually his entire cell structure has changed. That is, we somehow seem to consider individuality as extraneous to the human condition in the same way that the man

who says one can never step into the same river twice forgets that, part of what is internal to the concept of the river, is that one can never step in exactly the same bit of water twice. Rivers flow and change constantly – that's part of what makes them rivers rather than lakes or ponds. An aspect of a person is the fact that their cells change and renew themselves. (Although this is certainly not decisive in terms of personal identity, it is part of what we understand as a human being)

21. Loss of a relationship: can be corrupt if grief is informed more by position within society rather than love for the deceased. Can this be seen as a betrayal of the deceased? One needs to examine the difference between "being seen as betrayed" and "actual betrayal". Being seen as betrayed might tell us more about the cynicism of a third party rather than the supposed betrayer; but not always, as there can be general agreement about the betrayal of a lover.

22. Can one ever consider mourning as an expression of fellowship with the living (or dead)? – We will all die sometime, and although we often cannot make sense of our certain deaths, we can be consoled in the knowledge that we're all going the same way. This sounds clinical, but it's not meant to; although there is probably a psychological dimension to it, it is the question of the meaning of the deaths of others that I am interested in. What informs our sense of loss? – And is such a loss in any way conditioned by the realization that we all share a common fate? – Is this part of why we can mourn the deaths of animals?

23. When does mourning change into mawkishness? Can one mourn sentimentally (think of the reaction to the death and funeral of Princess Diana)? We can mourn the death of a pet, but why is it sentimental to mourn the death of a pet in the same way as one would mourn the death of a close relative? Can one come to terms with one's sentimentality and realise it for what it is?

24. What conditions an appropriate amount of grieving? What is an appropriate amount? How do we master such norms? How is grieving portrayed and discussed in films and fairy tales? What significance does this have?

↓

25. Just as a way of life governed by only simple commands and actions (say in apes) demands only simple signals and gestures, so a life with the possibility of love and despair must possess the possibility of signals and gestures (language) to go with it. All that occurs within humanity provides the limit for language – that is, what can be understood. (fiction occurs within humanity)

↓

26. An appropriate amount of mourning is conditioned and informed by the conceptual distance of a person or pet from us. That is how we can judge someone who mourns the death of a pet in the same way they might mourn the death of their grandmother, as sentimental (but that is not to say we will always judge them as sentimental). Similarly we can judge someone

who grieves for Princess Diana in a way that is not appropriately telling of his relationship with her (say, for example, this person had only ever seen her on TV and in magazines) as sentimental. Both examples show individuals who have been genuinely moved by the wrong things.

↓

27. One can never grieve for a pet in a way one can for one's dearest relative or loved one because the pet will never be "one of us." What does this mean? Essentially that there will always be a distance between humans and other animals that is marked out by humanity's rich conceptual heritage. Animals do not possess this conceptual richness and, as such, cannot partake in the forms of life nourished by love and grief. These forms of life also provide a conception of every human being as unique and irreplaceable, with their own fully independent reality. That this is not so in the case of animals is shown up by the fact that we keep them as pets (even if we cannot bear to get another pet after a particular favourite has died). We don't keep humans as pets (perhaps as slaves once, but never as pets), and this in itself puts a distance between us and animals. Not to recognise this distance is to possess a series of false beliefs about one's pet; moreover, if one does treat an animal as possessing nearer human attitudes, then to continue to treat them as a pet would be, in a way, grotesque (as it would be if we kept other human beings as pets). None of this precludes moral answerability concerning the treatment of animals, but it does make such answerability

different in character. There is no potential for closing the fundamental conceptual distance between humans and animals, but that possibility does exist between all human beings through, for example, morality being a dimension of all human ways of living (even if radically different in character). Animals do not have the conceptual apparatus that we have (otherwise there would be advanced animal languages that could potentially be understood by all). Of course, some animals understand – if that is not stretching the word too much – certain signs and gestures issued by humans; but these, if you like, are only tiny fractions of our realm of meaning; only tiny fractions that an animal can participate in. Nevertheless, one can still mourn the loss of an animal and the relationship with it, and one's mourning can also be appropriately telling of one's respect and love for that animal. But the degree to which an animal is "one of us" even if it is "part of the family" is expressed as (what marks) the difference between humans and animals. In other words, our mourning an animal can never be what it is to mourn a human being.

28. It makes no sense to speak of betraying a pet's memory in the same way as it makes sense to say one has betrayed the memory of a lover or WW1 veteran (unless one has false beliefs about animals).

29. Why think it is eccentric to acquire knowledge and education for the sake of it? Providing it is not displayed in arrogance, then surely it shows a greater appreciation of the world we live in and

provides greater richness to life? – Why should it be thought eccentric for a person to try to appreciate and understand more about his place in the world than is required by the kind of profession he has, or the sort of life he leads? Those who think such a person eccentric, presumably think he is eccentric because of his desire to appreciate and understand the place of humanity in the world. There are, sadly, those who see such people as eccentric whilst simultaneously working in the teaching profession. Such teachers appear to have forgotten what it means to have an education.

30. Why should examples from literature be taken seriously philosophically? A charge that is often made by philosophers to other philosophers is that arguments in moral philosophy are weak if they take examples from literature rather than real life; the implication being that the arguments can be undermined because the example it uses for support is fictitious. There is a certain truth to this charge (one feels like saying, "it depends on the example"), but I want to say why examples from literature do not necessarily undermine such arguments. Humanity understands itself as such because it exists in a common grammatical (logical) space. This space conditions, and is conditioned by, our individual attitudes (which lie at the heart of such space). Such common grammatical space gives rise to our understanding of humanity: it is what defines humanity, but it cannot itself be defined in terms of necessary and sufficient conditions. Grammatical space is made up of individual attitudes from which arise the

concepts that mark our consciousness. We can, through such grammatical space, perceive depth in another and we can, if we are sensitive enough, distinguish between examples that possess breadth of humanity and those that fail to do so. The latter kind (those that fail) would, indeed, undermine arguments in moral philosophy (or, at least, they ought to but frequently do not). But surely it's always better to take examples from real life? After all, no individual writer can think of everything. But any situation only has individuality participating in it, and no individual could possibly think of everything either. It is not as if a "real" example can be universalized any better than a fictitious one. And, indeed, the intention should not be to provide universalizing examples, since that denies the essentialness of individuality to humanity.

↓

31. But what else is there to appeal to other than humanity (and thus the concepts that mark it) when we want, or need, examples for moral philosophy? I want to say that those who believe that relevant examples can only come from real life, are attempting to appeal to something over and above humanity which somehow lends more authority to the example. – But a writer with a profound understanding of humanity, as such, has a profound understanding of the concepts that mark it. Surely, one can have real situations in which none of the participants have much of an understanding of the humanity of others (perhaps they're racist), yet this makes the

example no less important. The writer with a profound understanding of humanity will understand the different possibilities that make themselves manifest in real life. The problem for those who think that we should only use examples from real life is, I think, to do with how a real example can never be unrealistic. It is, perhaps, fear of not being able to distinguish realistic from unrealistic that worries those who say we should only take seriously 'real' examples. If taking examples from literature undermines arguments in moral philosophy then it follows that anything we feel we can learn from (fictitious) literature should be tempered by the thought that it is not a real example.

↓

32. A literary example can display the best and worst of humanity – the fact that this is intelligible to us shows what we consider to be human possibilities, and it is this that allows us to distinguish between realistic and unrealistic examples. We can be moved to tears by a novel, and we can be moved to tears by what we see in real life. Sometimes we might be genuinely moved by the wrong things, but this can occur as much in real life as it can in books or film. If an example is not intelligible to us as properly reflecting the human condition, *then* we can call it a bad example. There is no fact of the matter however, that allows us to distinguish the good from the bad in this respect.

33. Forms of the grotesque: earlier I suggested that if we mistakenly attribute near human attitudes to

animals and still keep them as pets, then this is a kind of grotesque behaviour, as it is surely near keeping other humans as pets. It is either that, or we are not really serious about our attributions of human attitudes to our pets. Can we say the same of people who are vegetarian because they consider the killing of animals to be murder? I'm not considering those who do not eat meat because they condemn the killing of animals; one can do this without believing one is committing murder. Some people cannot, morally, allow animals to be killed for food, and this is a manifestation of a form of respect for other creatures and how they see themselves in the world. That is different however, to claiming that such killing is murder. When such a claim of murder is made with regard to the killing of animals for meat, the claim needs to invoke the same terribleness as that which would be understood were a small child killed for meat. I wonder whether those who profess that the killing of a lamb for meat is murder would react in exactly the same way when it is served at the table, as they would were a dead person slaughtered and served for dinner. (cf. Gaita, R. *The Philosopher's Dog*. p198 for detailed discussion of this last point)

34. If someone is consistent in their views and, therefore, does not keep pets because they believe the killing of animals to be murder, then all that can be said is that they either have false beliefs about animals, or a diminished conception of what it means to be human. For we do not share our lives in the same ways with other species, as we do with our own.

35. The survival of the fittest depends on what it is to be the fittest. Dinosaurs ruled the earth for millennia, then a meteor strike and massive volcanic eruptions changed the rules of what it meant to be the fittest. Dinosaurs could not survive in the new environments created by these events; other small animals (mainly mammals) could survive in the new conditions. They were now the fittest.

36. What does it mean to "push the boundaries" of morality – say, in art? What are the boundaries? – "Pushing the boundaries" says something different to "deepening one's understanding" of morality. Sometimes, I think, the expression "pushing the boundaries of morality" is often an expression of admiration – sometimes it is admiration for something that really should not be admired. That admiration often stems from the thought that someone has been brave enough to think something that no one else can bring themselves to think. Sometimes that is justified, for example, when a painful psychological barrier that has acted as an impediment to living a better life has been broken. At other times it is not when, for example, it ignores the wrong done by pushing such boundaries. But how do we recognise the difference between a deeply entrenched psychological impediment and something that is genuinely beyond argument?

37. Often, attempts to "sharpen up" a concept such as love, end up as attempts to provide the concept with a series of necessary and sufficient conditions. To do this is an attempt to change the

nature of the concept and make it answerable to truth and falsity.

38. Because of the nature of the concepts that ethics invokes, it is not possible to deduce universal rules that can be universally applied – even if there is certainty in particular cases. But surely all moral situations have something in common? Yes, but not that can be determined by a series of necessary and sufficient conditions. It is possible, that one person may see a moral dilemma where another may not. And this is where the conceptual landscape provided by our individuality, enables us to meaningfully talk about such things, and allow for the possibility to disagree, persuade and so on. There then comes the question of objectivity; objectivity in this sense can be found in how we understand what it means to be individual in a human sense and, as such, understand human individuality. To be objective in this sense one must understand others as realms of sense and significance as we are, capable of being betrayed, loving, grieving, mourning, having passions, hating, having one's life torn apart by the loss of a loved one, and so on.

39. The man about to commit suicide cannot see why he should live. Reasons that weigh with the person who does not commit suicide will not weigh with a man who sees no reasons to live. – For the sincere relativist (of which there are none) none of it matters objectively because it's all just relative.

40. The man who cannot see why he should live and the man who cannot see why he should die, can be

given the same set of circumstances; one will see reasons to live and the other will not. It is what figures in their thinking that counts as a reason. None of that however, rules out a change in point of view.

41. If a man sees no option but to go on, and cannot see why he should ever want to commit suicide, it is the result of a set of reasons that figure with him; those reasons would not figure with a person who is suicidal. This is why relativism doesn't matter and adds nothing to any conception of ethics. In each case, nothing could matter more to the individuals involved.

42. It is a problem with reasoned discussion, that it cannot show despair in a way that allows anyone to understand why despair can prevent someone from having reasons to live.

43. Love is more than what we happen to want at a particular time. Would we mourn something this transient? In any case, we may desire something that our love will not allow us to fulfil. Similarly, our mourning may prevent us from satisfying certain desires. In this way there are constraints, and necessities of love and mourning that are as unyielding as those of abstract reasoning. Moreover, they determine what function as reasons in our lives and, as such, determine much of our everyday practice. This is not arbitrary in the way many desires maybe.

44. It is often all too easy to get away with an assumption of humanity in those we are

significantly removed from (for example, television personalities, celebrities and so on) that does not, in any fundamental sense, understand them as possessing the same kind of independent reality as we do. We do not see that such a person might be subject to the same forms of necessity as we are ourselves, with all the problems that compliance with such necessity might bring.

45. We only see the reasons that we do (see) and therefore can only act in accordance with them; we cannot act on things that don't count as reasons, because they would never be considered. If we consider something, then it is already acting as a reason – whether we choose to accept it or reject it is a different matter. In this, lies a form of necessity brought about by what we consider. We cannot act, as it were, outside of the reasons we have. This does not exclude the possibility of one being brought to see things afresh and, as such, encounter a revised set of reasons. Furthermore, we may be able to see how certain things might act as reasons, but that does not mean they act as reasons for us.

46. Of course, the compelling nature of necessity can result in ignorance, in as much as it blinds us to the point where we cannot see that it might not be so for another. Although we may be able to understand what makes a person, for instance, sad or suicidal, we will never in our understanding take on that person's sadness in the way he possesses it.

47. In ambivalence one is held captive and that is what makes one unhappy. To avoid ambivalence one must be whole hearted without becoming self conscious; if one becomes self conscious, one is already in the grip of a conflicting attitude.

48. All the reasons that one sees, whether or not one complies with them on an individual basis, compel one to act in certain ways.

49. Ambivalence is like a country in civil war – it makes for weakness. A person suffering from such inner conflict will become weak.

50. If disparate individuals become a self-conscious cohesive group – an intellectual one, for instance, such as the Vienna circle or Bloomsbury Group – propounding sets of ideas, then one is already somehow in the grip of conflicting attitudes. Such self- consciousness betrays such groups as caring as much for their elitism as for the truth in their ideas. There is no *whole* heartedness (except perhaps for the welfare of the group and its reputation). The group would come together naturally with no further thought for motives, if the search for truth through their ideas was all they had in mind. And they would part naturally too.

51. What makes a game such as chess or cricket a game? Is it to do with it relationships with are other things that we also call games? Partly, but it is mainly to do with the role that such activities play in our ways of living. That is why activities as diverse as football, patience, darts, patience and pooh-sticks are considered games.

52. A problem: suppose there is a machine that tells us everything that will happen tomorrow and ever after. Today I play the game – tomorrow I will carry out precisely the same actions; tomorrow arrives but I do not think I'm playing a game. Despite my actions being exactly the same – thus vindicating the predictions of the machine – I do not see my actions as a game or even as part of the game. So the future is also not as the machine predicted: I no longer think of what I'm doing as a game but I still *know* what I'm doing. I can say: "this is not a game!"

53. To be ambivalent is analogous to having doors slide shut over one's personality; that is, ambivalence suppresses what one would be if it is absent. One is trapped by not knowing, and this will result in frustration and possibly despair. We are denied the freedom granted by certainty.

54. If one has an understanding of what it is to be an individual - that is, an understanding of another's independent reality in the form of their desires, interests and projects, and an understanding of them as an intelligible object of love – that they can be loved as a parent, son or daughter, wife or husband and so on – then one cannot avoid morality. In other words a moral situation is just that; there is no moral component to it that can be removed to allow one to see it free of its moral dimensions. Of course that does not exclude the possibility of ignoring such dimensions.

55. One can describe two kinds of compassion: 1. That displayed by those who pity those weaker

than themselves in a way that is considered. The consideration represents the kind of condescension brought about by an acute awareness of the distance that the disparity of strong and weak creates. That is not to suggest that such people would ever be intentionally condescending towards those weaker themselves or in suffering. Sometimes there is a conflict – a kind of ambivalence – between appreciation of their weakness or suffering and not seeing their preciousness as human beings somehow diminished. 2. A compassion that leaves the individuality of the weak undiminished in every way; to be treated as an equal in every way. Such compassion is non-deliberative even when there is a massive disparity in strength (mental and physical ability for instance) between two people; this is the compassion of saints. The non-deliberation shown by such people is of the same kind as that shown by a loving father playing with his son in the park: he does not think that he ought to do it because he loves his son; rather, he just does it, and that is the manifestation of his love for his son. There is no thought that I must try not to condescend to this person or that I must try to play with my son.

56. Our attitudes toward other human beings not only exist prior to any psychology, but also determines connections we see within psychology and the nature of that psychology. When we judge someone as sentimental, the judgement is a result of connections we see between this individual's way of living, and others; these connections are certain to us – we do not think: "it is certainly

possible for one to make a connection here!" In other words, such connections are non-deliberative and are part of the perspective through which we understand others.

57. There is another way of seeing why concepts such as sentimentality do not admit of absolute standards; they only find their form in individuals, being a part of what makes up an understanding of individuality; and there can be no standard of individuality (even if there are social and cultural norms that give rise to understanding of normative behaviour). Such aspects of living can only, finally, be shown up by examples of what they are not, and their ascription reflects as much (conceptually) on the critic as the criticised.

↓

58. Something similar to this thought is what marks out femininity from masculinity. There is no cognitive/non-cognitive dimension to these concepts; there are forms of thought and, as such, ways of looking at the world that give rise to such concepts. Neither one can be true-valued against a background of propositions that go to make-up what it means to be masculine or feminine; and one cannot, therefore, come up with a definitive standardised answer as to what the difference amounts to. It is our practices that give rise to the concepts that mark our consciousness. When I talk to you, I talk to you in a way that responds to you as a particular person. That response is a non-deliberative appreciation of you in all your particularity – that is, an awareness of your

individuality. This is why, for example, we feel comfortable talking about certain things to some people but not to others. When our responses are honest and free of presuppositions about the person we are talking to (for example, that this person is a woman and therefore should be responded to in a certain way), then our responses reflect the individuality of the person. I do not respond to a man or woman and then to the individual; awareness of masculinity and femininity arises through how we respond to others - and it is that which gives rise to such concepts in our ways of thinking about people. It is only when we allow thoughts of masculinity and femininity to precede appreciation of the individuality of the other that we become sexist. In other words, we become sexist when we allow the fact that somebody is a man or a woman to precede anything else about them. It is a kind of denigration of individuality, which is why it is so objectionable.

↓

59. It is an important general fact that femininity is found more in women than in men and masculinity is found more in men than in women. That is why each is tied to its respective physical sexual category. But it is not legitimate to then precondition our responses to men and women on such grounds, because such preconditioning ignores the conditions through which the concepts (thoughts) of masculinity and femininity arise at all. Indeed, it changes those conditions to the point where we ignore an important dimension of

a person's individuality. The same can be said about reacting the other way around – that is, to remove all thoughts about masculinity and femininity from responses to others. In this case, we allow such an idea to precede anything else about the person we are responding to. That is also a neglect of individuality. We should allow the possibility of masculinity and femininity to arise in both sexes if we wish to be sincere about being sensitive to the individuality of others. There is no unconditional connection between a person being male and an ascription of masculinity, or a person being female and an ascription of femininity. It is important to see the difference between the existence of a general fact and a necessary connection.

60. Some ask: "but surely there is a necessary connection, because on the evidence of such general facts, it would seem daft to suggest there was not?" - This is to see a connection in the wrong place, so to speak. A general fact exists because of a general occurrence. It is a fact that femininity is a characteristic of women much more than it is of men; similarly, it is a general fact that sad music is generally in a minor key. The connection is not between women and femininity nor is it between minor keys and sadness. Our responses to each other - our practices - condition the way we think about others. Awareness of masculinity and femininity arises through how we find and respond to others - and it is that which conditions the concepts we use in our ways of thinking about men and women. The connection is not between being female and

femininity but between our practices (responses) and the concept (of femininity). Similarly: music speaks as it speaks; there is no necessary connection between a minor key and sadness but composers express themselves in ways that allow us to legitimately make such a generalization. After all, there are joyful pieces in minor keys and reflective melancholic pieces in major keys.

61. There is a necessary connection between language and our forms of life: language is a part of that form of life. Similarly, there exists this same connection between ways of living and art, music and poetry.

62. I feel I could go so far as to say: "There is a relationship between sound and the affective world, and such sound is in language!" – In other words, language comprises particular sounds that affect us (are meaningful); a receptivity to such things is the basis for language, and sounds in particular combinations that form other sounds are what it is grounded in. – Maybe I go too far here?

63. A realm of meaning in our lives is woven into the forms of our lives. The realm of meaning abstracted from the way we live becomes meaningless because there is nothing to nourish meaning; without "our lives" a realm of meaning would be senseless. It would not be a realm of meaning. Thus, a realm of meaning is a part of the fabric of our lives – our lives would be senseless without it, and the realm of meaning would not be a realm of meaning, in the sense that it would

provide meaning for nothing if there was no form of life into which it was woven or meaningful.

64. The connections one is disposed to make reveal something of the kind of person one is. Some people might see a similarity between oppressive heavy dark gothic architecture and the prose style of Hegel. What are the connections that we see here? It is certainly not senseless to say such things.

65. The concepts that mark the kind of understanding we acquire through being moved are necessarily, but not merely, personal. They are not merely personal, as that would amount to personal (subjective) idiosyncrasy and undermine any authoritative examples of understanding acquired through being moved – for instance, a deep compassion for nature. That said, it is our humanity that underwrites the possibility of being moved, and that is what it means to say that they are necessarily personal. Simply personal is that which is related only to the idiosyncrasies of a particular individual.

66. There is a difference between an artificial intelligence being programmed to make random connections and thus gain individuality that way, and what it means to have depth of experience with regard to it.

↓

67. The difference lies in depth granted by a form of maturity, and that such maturity necessarily takes time to achieve; it cannot be granted by a series of

Philosophical Notes

programmed commands or true propositions as in the case of the AI (artificial intelligence). The individuality of the AI would be superficial – only running as deep as the unique connections it was programmed to make. Also, such connections (the programming of them) would be completely unrelated to whatever else it could do, or had the "intelligence" to do. This differentiates it from profound individuality in as much as: 1. We are moved to make such 'connections' 2. The kinds of connections are related to the manner in which a person looks at the world – that is a distinct aspect of their individuality. An AI would have to know how to think about concepts that do not admit of external justification – this is not possible since the AI would have to know how to think correctly about them and that would require absolute standards. Such standards would be required in order for it to ascertain depth, and that would mean "depth" would be made up of a series of correct propositions that go to make up what it is to be deep. Why couldn't an AI be made to think like this? – Because we would have to give it a soul! We should have to give it the ability to recognise authoritative examples of, for instance, a genuine compassion for nature and counterfeit examples of it. Since there are no necessary and sufficient conditions relating to such recognition, it is difficult to see how such an "intelligence" could be programmed. Such authoritative examples can manifest themselves in profoundly different ways in different cultures. And the only way that an authoritative example attains its authority is through examples of what is counterfeit. How would AI cope with different

cultures and the multitude of different ways in which moral purity is expressed, for example?

68. Knowing how to go on is a line of reasoning.

69. Suppose I win some money, and suppose that it is a substantial amount. I decide not to tell anyone for a variety of reasons (e.g. begging letters, emotional blackmail etc.). Suppose also, that at the time, I'm not in remunerated employment, but that this money gives me an income on which I can live well for the rest of my life. Nevertheless, I feel that I ought to say that I work (for money), particularly in certain company (say because of vanity). Now, suppose I'm at a party and someone asks me what I do. My answer is that I work for a wildlife trust (which is true insofar as it is voluntary). However, I know that the questioner is asking me about my professional career, which is non-existent. Thus I have not said anything that is false, but have nonetheless lied (some use the expression "been economical with the truth" in this respect). So, there are two points here: 1. I know how the question was intended (I recognise the spirit in which it was asked). 2. I give an answer that is not untruthful but which invites inference to false belief. I do voluntary work for a wildlife trust – so I work for them. That I am paid or not paid did not figure in the question, so my answer was not untrue. But we know the sense in which the question was asked, and we understand that it is common to use this form and to get truthful answers (in everyday life). If it was not common to use such a question in this way we could have authoritatively said that the

person was stupid to ask the question in the form that he did. For it is the regularity in our practices that conditions a sense of good judgment and bad judgment. A consequence of this is that judgment is always fallible.

70. It is not reasonable to say that exploitation of an ambiguity meant there was nothing wrong in what I said, nor is it reasonable to say that it is the questioner's problem that he has gone away with a false belief about my life. In this case, that he went away with a false belief might be enough to say that I had lied. Sometimes it is not however, and is just down to lack of clarity in the answer, or a way of thinking in the questioner that blinds him to the intended meaning of the answer. To doubt the truthfulness and sincerity of the kind of answer that I gave to the question would be a manifestation of cynicism. Indeed, if a person always doubted the truthfulness of a response, if there was an ambiguity of the kind shown in the question above, then one would think him to be paranoid. One might say that such a person was not doubting sanely. There are further points: 1. There are times when it is rational to doubt –for instance, if we know someone to have a dispositions to be economical with the truth. 2. What then, underpins the possibility of rationality? The answer, I think, lies in our common practices: if it were the case that language functioned in a way that threw doubt on questions and answers of the kind I have been speaking of – that is, if it was natural to accord importance to an ambiguity within a question or answer, whatever the circumstances, then one

would say that it is not cynical to doubt truthfulness or sincerity; indeed, there would be nothing remotely abnormal in our doubting. In both cases however, there is room for error. Error of the kind that allows one to be right or wrong without the possibility of a legitimate accusation of irrationality being made. In other words, on either model – the model of language as it actually functions, or the model in which it is natural to accord importance to ambiguity within any question or answer – there is always the possibility that one may be wrong. On the first model, one might be wrong in one's understanding of the person's life. On the second model, one might be wrong as a result of according importance to the ambiguity within the question and/or answer. However, such wrongness cannot be attributed to irrationality.

71. If there had to be no ambiguity for rationality to be ascribed, there would have to be definite answers as to whether, for instance, a wife loved her husband. The husband would be able to know in a way that could never admit of any ambiguity. It would not be a case of wondering whether her tenderness and joy in his company meant that she really loved him. Rather, it would be a question of factual evidence – this would be what counts as rationality. (Yet, through our understanding of love we can see that this is not rational.)

72. Our forms of expression attend certain ways of thinking and understanding. One cannot consider the meanings of our lives without considering how we think about them. This is how we can

distinguish good and poor literary examples. That we find significance in certain things often finds its form in the expressions that we use. When this is so, it is often not possible to convey such significance in neutral re-description. The language of a good love poem is one such example. Speaking of one's offspring as one's "own flesh and blood" as opposed to "biological product" is another.

73. And we would think it odd – possibly alarming – if someone abandoned the critical concepts of morality because the conclusion of a valid argument left no room for them. That the lorry driver, of Bernard Williams' famous example, should abandon feelings of horror and guilt because he was in no way responsible for what he had done, would seem odd in this way. What is it then, to loathe a conclusion yet see nothing wrong with the argument that led you to it? Does this show that there is something missing from a conception of argument? In short, a proper model of reason and argument has to do with the way we live, how our lives are marked by our practices (in the broadest sense) which, as such, give rise to the ways in which we think about them. Conclusions that we can seriously entertain without being branded insane, fit into an authentic conception of reason and argument. As our perspective changes, what we are willing to seriously entertain and rule out, changes also; that is interdependent with what it is to have a perspective. Such changes usually take place over considerable periods of time in an ever-continuing process. That is not to say that these changes are always of a kind that result in

ways of living that are good for us (or progressive – whatever that can mean).

74. The awfulness of rape is informed by, among other things, the significance that a sexual love can have. Similarly, an awakening to the individuality of another which transcends their individuating features (such as musical tastes, charisma and so on) is at its most heightened in love. And it is love that provides our lives with some of the greatest significance we are ever likely to know – in the form of realising the full individuality of the other, that is made apparent to us in our loved ones. Understanding profound human individuality is to grasp each and every one of us as an intelligible object of love. It is this kind of significance, and awareness of the other, that provides us with a conception of individuality that treats others as unique and irreplaceable, over and above their individuating features. That love can inform in this way, not only provides the significance that individuality can have, but places the concept of love firmly at the centre of attempts to deepen understanding of our moral answerability to each other.

75. There are a number of ways one can look at a poem – authorial intent, the subject of the poem and so on. – But there are many instances when a poem 'speaks' to its reader in a way defined by the poem itself. If it was any other way, then that meaning would go dead and perhaps other meanings would appear (or perhaps not?). In this respect, the poem is an expression of a particular kind of thought (and way of thinking) that finds its

feet in a form of language (expression) that characterizes such thought. And we can learn a great deal from such things. Yet there are some who will claim that there is not a great deal of content, beyond emotivist dimensions and interesting psychological content, to such forms of language and the thoughts they characterize. They will not, for instance, be keen to accept the idea that the way something is expressed is sometimes fundamental to the content of what is being said. Yet often, such language shows up ways of thinking that give rise to, and are characterised by, certain expressions.

↓

76. Why do people have poetry at funerals and weddings? – People who, otherwise, pay very little attention to it? The answer is that it expresses a kind of thinking (some might say depth of thinking) that cannot be conveyed in any other way. When I reflect on a poem, the meaning of which I find deeply moving, my thoughts about that poem are answerable to a distinct form of understanding, characterized by concepts that mark out a particular way of thinking about its subject matter. These forms of thought, and their attendant forms of language, are often required to nourish understanding of love, friendship, hatred, evil, depth, shallowness and so on; things that we talk about in everyday language, but in a way that allows us to encounter at least something of what

they are. As such, these forms of thought and language can express certain truths.[4]

77. (McDowell) Take the phrase: "spring has sprung!" Does spring spring even if we have no concept of it? Let us first consider how the concept of spring arises. It is similar, I would argue, to the ways in which concepts of colour, measurement and so on arise. If we could not perceive colour, irrespective of whether there were colours, that would *be* our not having the concept of colour. Even if we could measure the wavelength of light etc., that would (still) be a different kind of agreement that would have absolutely nothing to do with colour (that is, the way in which we see it and generally agree about it). Similarly, we would not have the concepts of weights and measures, if things randomly changed in size and shape. In other words, it is a form of life – our practices and so on - that provide the grounds for the concepts we possess and use. Thus, the concept of spring as the season, is related to our way of living, and what we find significant. So, we might consider plants growing, the weather improving, other practices that such climatic change allows for, the quickening pace of life in all of the natural world that comes with the onset of spring. All the signs of spring would still be there even if, as in the colour example, it did not impinge on us as it does. But then spring would never spring! "Spring has sprung!" would be nonsense. We have the language to describe the

[4] Propositions can exist independently of certain expressions; that is where words can exist independently of expression.

conceptual landscape that makes up our understanding; indeed, such language is a part of such understanding, with its own part to play in the shaping of our concepts and their place in the conceptual landscape. We cannot sensibly consider the possibility of our language describing things that exist outside the scope of our conceptual awareness. Where would such language get its authority from? We would have to say that language is wholly independent of our ways of living if we were to coherently argue that it is possible to describe things that exist outside our conceptual scope, in the same way as we describe things that exist within it. This is just an incoherent idea. Our world is no more independent of us than the words we use to talk about it.

78. Reason and rationality: are two different things. What is rational for us conditions our sense of reality; reason is necessary within this, in terms of what follows from what, and leading towards other things that we may find rational. Rationality itself however, is a capacity that we have to greater or lesser degrees; what is rational and irrational is not always provided by pure reason.

79. Many of our philosophical doubts dissolve when we return to the realm of everyday living; I do not think, for example, that I might be dreaming, or that the existence of the external world is nothing like I know it. It is the realm of everyday living that is primary in conditioning our understanding of the world and of others. It is not the realm in which we doubt things that we otherwise do not

question (like in the realm of philosophy); for otherwise, it would be these things (and this realm) that characterized and conditioned our understanding of the world, with all the differences that would accompany such a way of living. Such differences in practice would lead to a completely different conceptual landscape; a completely different way of living.

80. If we rid or, at least, try to rid our minds of the contrasts we see and what we find significant in our everyday lives, then we rid ourselves of the conditions that characterize our understanding. What's wrong with this? Maybe we are wrong? Maybe we should try to think about certainty always in terms of percentage? But then we are being asked to live an entirely different life, with all that that entails. Can we accept this? Is it even possible for creatures like us? Ultimately, some facts are facts because we are the creatures that we are. The impact that other people and animals (with their respective expressions and capacity (or not) for living in various ways) have for us conditions our sense of their reality. Not every assumption, through which we attribute certain capacities to others, should be transformed into a hypothesis that can only be confirmed or falsified on the basis of external, empirical evidence.

81. Because we are the creatures that we are, certain things become facts –for example, the way we respond to one another (we respond differently to another human being in the street than we do to a dog, pigeon, lamppost or pillar box). These 'facts' are as such because of the various forms of impact

that different things have on us. Further examples include: the significance of animals as wild beasts, and the significance of animals as pets, how we understand them as sensate beings (and so on), how we can love them, what informs our understanding of the differences between a pet and a wild animal: what is the significance of a pet? What is the significance of a wild animal?

↓

82. And then, of course, we can see that the above 'facts' are interdependent with the kind of creatures that we are.

83. A common solution to the problem (and question) of how we know – or whether we can know – that animals are conscious like we are, works along the lines that we can be, for example, 85% confident that they are. The grounds for doubt, the thought continues, are not great enough for us to worry about. But this is not a justification for the argument that animals are conscious as we are.

↓

84. So how do we know? Some would say that we just know on the grounds of some form of intuition. We cannot, surely, use intuition as justification for knowledge. Intuition is akin to having the feeling that your girlfriend is going to be late meeting you because you think she might have looked round a couple of extra shoe shops. Indeed, it might be more vague than that: it might just be a feeling that, in this particular case, she might be late. These examples define the scope of

what can be termed intuition. Thus, it is possible to see that intuition cannot be used to settle the 85% problem (even if we can say: "I just know!")

85. What conditions the word (or, rather, the meaning of the word) "consciousness" in the first place?

86. Sometimes we are touched by events in our lives that we would normally let go unnoticed. – Perhaps the urbanity of the underground with its busy people immersed in what they are doing, going to and fro at various different paces, in various different manners depending on what is demanded of them that day, or what their physical capabilities are. Perhaps one is touched, sometimes, by the everyday goings on in a shop, and the significance that such events have for the shopkeepers and their customers. This being touched (on occasion) is part of what marks (and informs) how we understand our lives (and our multiple forms of life) and, as such, our humanity. That it does not occur continually also informs the way we live, and conditions the concepts we use in our understanding of the world.

87. Sometimes the connections that we see between things determines their significance for us – for instance, humour, and when we make connections between things that we find humorous or funny. If another person does not make the connections we do, the significance of the event(s) will be different. This can affect human relationships and even allow for, or preclude, the possibility of love between people. But that does not mean that we

should see some people as not being intelligible objects of love.

88. What about the notion of "opposites attract?" That is something that two different people may find significance in a way that is attractive. It does not constitute an objection to the idea that the significance of others for others will be affected by the kinds of things each individual finds significant, because individuality is, in part, determined by the kinds of things we find significant, and that (in itself) affects the kind of significance that we can have for others. Also, the kinds of significance we have for each other partly informs our conception of the individuality of others.

89. That we find certain things or individuals significant, is something that is unreflective. That certain kinds of things trouble us, fascinate us, amuse us etc. often encourages us to reflect on them.[5] About other things we can be entirely unreflective; whether we are reflective or unreflective in connection with certain things and events, often depends on the context in which they occur (including the people involved). Yet the significance in itself, always remains unreflective and immediate. That we care about our relationships with others, that we see evil and love in others, that betrayal can embitter us, that a man worries about whether his partner really loves him - all these things are part of a human life. What of

[5] Some of us are more reflective than others and this can be significant in itself.

a life in which there was the same intellectual power but none of these things? Would we be able to call that life a human one?

90. It is our intellect and our capacity for language that separates us from animals (that is, the capacity we have to publicly reflect on our lives, realise when we have taken the wrong turning and so on) but, at the same time, it is the significance that such things have for us – even their very possibility – that gives us our humanity.

91. Multiple bodily expressions are aspects of everyday life and, simultaneously, an aspect of language (why else are they called expressions?). Thus bodily expressions in which we see fear, partly condition our concept of it; furthermore, without such concepts we could not ascribe states of consciousness. Concepts such as fear are, at least in part, necessary for us to ascribe states of consciousness to other creatures.

↓

92. But how do we see fear in another creature? - Their faces and bodies are nothing like ours, so how do we know what to make of their expressions? How do we know that they are in fear, or whether they are cross? Surely we understand them as such by seeing what their reaction is like in the shadow of certain events (for example when their life is put at risk)? – But even then, how can we be sure that it is fear they are experiencing? We understand animals as fearing in the shadow of certain events, and we might think it odd if they did not react in this way. To say however,

that we understand an animal as fearful through their reactions to certain events gets us nowhere – it could just be a different reaction; their reaction to food is a different reaction in the same way. It is not like ours, so we can't say it is behaviour like ours.

93. We understand animals as being in fear (or looking bashful) through the roles that they play in our ways of living, and the concepts that we use with regard to such roles, are those that are necessary for us to make ascriptions of consciousness at all.

94. What moves us is part of the apparatus that forms and conditions our ways of living and, as such, our concepts. In this respect, how we are moved is important, insofar as it shapes our sense of the reality of others.

95. The role of bodily expressions, the accents those expressions take, their mode of delivery and so on in meaning and understanding, and how this relates to an understanding of people's characters: such things are pivotal in how we assess, and conceptualize, character. All these expressions are aspects of our activities in everyday life, and partly determined the meanings of the words we use to describe them (and the characters who have them).

96. [6]

97. One of the biggest struggles for western academic philosophy is to retain the form of seriousness in the problems they examine, as they present themselves in ordinary life. Too often, the problems become distant from the grounds on which they were conceived. When such distance occurs, something very important is lost – in part, it is that something which is often a dimension of seriousness that puts an idea or argument beyond serious consideration. The worst part of it is that in academia one also has to impress others; if the seriousness of the problems as they manifest themselves in everyday living departs, I find myself not knowing why I'm doing philosophy. Many in academia seem to be impressed by the wrong things (for whatever reason)!

98. How others affect us and how we respond to them is, in itself, born from a kind of understanding granted by the accents of our expressions.

[6] Can philosophy ever be a profession? For this, I'm going to take philosophy as meaning "love of wisdom". Obviously, in a sense, one can teach philosophy and this involves teaching how to think critically, engage with the ideas of others and so on. But can we teach wisdom? Part of the concept of wisdom is that it is not merely subjective opinion, though some may say that it is by contrasting it with knowledge. I may think my Auntie Dorothy is wise, but her husband may not. So, how are we to determine what counts as wisdom? Surely it just boils down to a form of complex subjective opinion? Firstly, the very concept of wisdom would not exist if there were not various ways of contrasting it. Secondly, there is a background of critical concepts that mark our various ways of living with one another. The deeper one's understanding of others is, in this respect, the wiser one might be said to be. (or not?)

Essentially then, we are moved by others, and this is fundamental to our understanding of them and the concepts that marks such understanding. If I'm looking for evidence that others have sensations as I do – sensations, the nature of which is hidden from the outside world – then I will not find any. All the subtle bodily expressions in the world will do nothing for my certainty in a purely evidence based investigation into such things. Thus, our being convinced of someone's fear, love, masculinity, femininity and so on – apart from being concepts that are necessary to ascribe states of consciousness at all – requires a kind of imagination for them to be even possible. For we cannot, sceptically, say that supposition is equivalent to certainty. Thus, this kind of imagination is actually a part of our epistemic faculty. It is part of our form of life that we are imaginative in this way; if this were not so then: 1. Our language –in terms of such critical concepts – would be very different. 2. Related to this, our understanding of others (through a different form of life) would be very different. We might be wholly unimaginative and, thus, rely on a purely evidence-based epistemology.

↓

99. So, just like the Wittgensteinian notion that we could not have the concept of colour, irrespective of whether there are colours or not, we would not possess concepts such as fear, love, masculinity and femininity, if we did not have the epistemic capacity to do so. And this capacity lies in a peculiar kind of imaginative ability; by that,

I mean something not wholly (though, by no means excluding it) grounded in an evidence-base. Imagination in this way underpins our certainty. Yet, we talk about creatures –insects for instance – in terms of struggling, and this would seem to imply that we are ascribing a state of consciousness to them. But it makes little sense to speak of an insect as conscious. So it would seem that our imagination does not act in the same way as it does with humans and other mammals. Nevertheless, we see them as 'alive' through the imaginative capacities that we possess. So, the idea that our imagination differs with regard to animals is suspect, insofar as the attenuated sense in which we share our lives with them is a product of the imagination, through which we understand each other as human beings.

100. If an explanation fails to live up to the original expressions; if it fails to show in its explanation the moral terribleness of what is done, then it fails in its task as an explanation.

↓

101. Can explanation deepen our understanding of the other, or the nature of moral response? Is there any obligation to "translate" such expressions as, "Oh no! What have I done?" into explanatory terms? Yes and no. Yes, insofar as an explanation can bring you to see something in the original expression which previously you had missed. No, in the sense when the explanation does not have the impact of the original expression and (or) could not replace it.

Philosophical Notes

102. People seem not to make the link between our everyday habits and our evolution as a species. If we take Darwin's theory of evolution to be substantially true and, take also, the idea that casual sex has increased in the past 100 years we can, perhaps, talk about changing human mating habits. Perhaps this is also something that will, in many years time, be seen in a wider context of changes in our species –for example, the *way* we think and the *form* that our thoughts take (characterizing the way we think).

103. Love is internal (necessary but not sufficient) to our understanding of moral significance and, as such, a part of how we understand others. – It is a part of our epistemic apparatus through how it conditions our understanding of others as independent beings, and through this, shapes their moral significance. That we see, in every human being, the possibility to love and to be loved, in part, conditions how we conceptualize a human being.

104. Where does the authority of language come from? - Essentially, from our practices. Language is a part of our way of living; a way of living in which there is a need to communicate and express oneself. The forms of such expressions within a language result from the practices that we are collectively and individually engaged in, and the concepts that mark our lives are interdependent with these. Language belongs to a life as it were – its form and our forms of life are interdependent with one another. – It would make no sense for a language to exist without a form of life in which it

could be used; indeed, if such a thing did exist in such a sense, it would not be a language. Some might argue: "It still has rules, syntax etc., so it must be a language." - But if it is wholly unconnected with any form of life, then how do we know - what gives us even the slightest idea - that this "thing" has rules? If there are rules, then we must have some knowledge of their application or, at least, realize that they can be applied. The mistake that is often made here, is to think that language is only something that we all share – something that is made up purely of words, phrases, sentences and so forth; rules from which we can determine whether we have used the language correctly. This is so (we *do* all share it), but it is so in a way that is inextricably linked to the limits of our practices. So, of course, we all share a language but language is also something that cannot be separated from the individual, because it is also *his* language through which he expresses his individuality. If it were not his language in any profound sense but only in the sense that he might speak French or English, then one could never speak of him standing behind his words. Language, in this sense, could only be a tool that performed certain functions. It is our practices in their fullness (including the richness in nuance of expression) that gives rise to language, not language to our practices.

105. The fact that our moral obligations sometimes conflict with our obligations towards those we love, is partly constitutive of the character (concept) of love. And this is what informs, and is internal to, the seriousness of love (based in the

reality of moral significance); an obligation born through love is not necessarily a moral one. This is also what individuates love and transforms our understanding of other human beings as fundamentally individual.

↓

106. When parents lose their offspring, the focus of their grief is partly symptomatic of an understanding of the deceased as individual in a way that is not answerable to a celebration of difference; as is pity for the bereaved and those who mourn them. In their grief, the parents do not just mourn any human being, and in our pity for them we do not just pity any human being. We mourn and pity a human being in all their particularity. Genuine pity, for those who have lost loved ones, focuses wholly on particular persons; it would be difficult to conceive of it as genuine in one who pitied because an example of humanity had been killed. The concept of fundamental individuality that, I think, is necessary to see others as fully human, is located in our responses and thoughts about a person and, as such, integrated into our practices. If that were not so, then the love, pity, and anger we focus irreducibly on particular individuals, would be extraneous to our understanding of their moral significance.

107. Though an understanding of others as intelligible objects of love conditions much of our understanding of the moral dimensions in our lives, love itself can radically separate individuals

from morality; sometimes it can make people do morally terrible things. One cannot have fellowship in love, although there can be many people who love the same thing (consider love of country).

108. Language is itself a form of life – a form of our living; it is a way of living. This way of living is bound up with every other part of how we live our lives, and our acknowledgement of it is interdependent with language as part of that way of life.

109. And we need to understand what constitutes language. – There is nothing we can point to independently of everything else and say: "That is a language!" – We can understand something as language through its relationship (or connection) with something else that we recognise as language and its relationship with a way of life. That is part of what makes the human way of life distinct from a gorilla's way of life. Although some gorillas use basic signs and gestures to communicate, they do not possess language (as we understand it. And how else are we to do so?) because their way of living is so far removed from ours. Of course, many of these connections are different, and if such connections were not as they are, things would be different. Thus connections and differences are as important as each other in our understanding of what counts as language.

110. Art is a different form of expression – it is an absolutely individual one; art can, obviously, have linguistic form (such as prose and poetry) etc..

And this is where language is capable of showing individuality. But such expressions may also take on many other forms: music, painting, other forms of visual arts such as dance. It is important to remember that all these forms (and they may be infinite) are individual responses; such a response dictates the form, as well as the format that that form of may take. Some may ask about the "validity" of the art if it is conceived by one person but put together by someone else or many others. This may not be a good question. The response to the way of living which has moved the artist to respond in a way that involves others creating his response (art), must be internal in some sense, to the character of it. It may be that it needs – for some practical reason – many people to realise it, in which case the artist needs to be satisfied that such a circumstance does not corrupt the realization of his response. Or, it may be that part of the character of the response relies on its being realised by others –so the reason for others creating one artist's work is ideological (in this respect at least). It does not follow however, that his response runs the risk of being compromised in terms of whether it should be considered art as a result. The question of whether something should be considered art lies elsewhere, in different conceptual space.

111. Sergiu Celibidache: "I do not believe that we do music; we create conditions that this beauty could materialise for ourselves. We don't do anything. We might ignore the whole landscape of the piece, as most people do. But we do not create it; it *is*

there.... between doing music and having a fantastic orchestra, there is still the difference."

↓

112. Music cannot be made in an impersonal way; some might say that this is obvious, but there is a curious problem here. Often one hears people talking about interpretation of music – interpretation is often understood as the way a particular conductor wants a piece to be performed; it is a particular conductor's interpretation of this piece of music critics often say. This is analogous to the non-cognitive dimension of the model of thought which asserts that thinking is either cognitive (justifiable from outside human subjectivity) or non-cognitive (an aspect of human subjectivity such as feeling). If in music there is the possibility of interpretation there must also be the possibility of standard performance. But what is standard performance? And can an interpretative performance ever be a perfect performance? Can interpretation run the risk of being too far away from what the composer originally intended? Is what the composer intended always the most musical? What are the cognitive dimensions of musical performance? These questions, I think, are misleading. They imply that a definitive musical performance rests on something external to any of the performers; that there is something that both performers and conductor can appeal to beyond themselves in order to get closer to the possibility of such a performance. To understand music properly and, as such, what it demands of us in performance

both as conductor, performer, and listener, we need to understand the role of music as a form of expression in human life; as expressing forms of thought that cannot be expressed in any other way. Only once we have done that, can we understand the demands of tempo, phrasing, what compensations or compromises need to be made due to acoustics, the quality of the players, the quality of the instruments the players have at their disposal, and so on. Music is part of our realm of meaning – that is at the root of why we make music at all.

113. Some people say that music is mathematical, or that music is full of mathematics. A few go so far as to say that music is a branch of mathematics. Certainly, there is plenty that is of mathematical interest in forms of music such as fugue. However, it is not mathematical content that makes music; we seldom (if ever) express ourselves through mathematics, we do so through language (have you ever read a play or novel in numbers or algebra?). Musical expression is an expression of forms of thought in which cognitive and non-cognitive content cannot be separated. We could not express the same thing through mathematics or poetry or narrative prose. Those who say that music is essentially mathematics are wrong. But that is different from saying that there is nothing of mathematical interest in musical analysis; that said (as I discuss in the paragraph 287), all forms of musical analysis only exist on credit from what they analyse, so to speak, because none of them would be understood as musical analysis without there being something

understood as music that existed prior to their formation as disciplines. Musical analysis would not exist without there being something meaningful – music – prior to that analysis. If mathematics could do everything music could do, or if it were argued that musical notation is a form of mathematical notation, then Bach's Brandenburg concertos and certain forms of mathematics could express the same thing; they could be meaningful in the same way. That is not so; we cannot write and understand music or poetry in a mathematical language; there is no mathematical language that can do that. If there were, it could say the same things as music, poetry or prose and (as such) would not, in that respect at least, be distinct from the language of music, poetry and prose.

↓

114. Thus, mathematics has nothing to do with musicality – nothing to do with how music can contribute to, or nourish, meaning. So, the essence of music is not mathematical; maths can, in no way, nourish that kind of meaning, and it is a certain kind of expression with a certain kind of meaning that allows us to say that something is music at all.

115. It is frequently commented that a conductor needs a degree of arrogance and ego in order to stand up and tell an orchestra or choir his interpretation of the work. Quite the opposite is true if music is to emerge. It is not music – and does nothing for musical expression – to "interpret" anything.

Music speaks as it speaks (as I speak how I speak): one cannot, with musical honesty, take an interpretation of a work to any orchestra or choir.

↓

116. If I shout at you from across the room, the tempo and volume of my speech and how I enunciate words will vary according to (how I respond to) the conditions such as acoustic, the timbre of my own voice, where my interlocutor is and so on. All these things (and many others) necessitate that I have to change my expression according to what I'm confronted with, as well as what I am saying and its meaning. If I'm in trouble, for instance, my expression will also reflect that. If I'm just asking for a cup of tea, the conditions are different again; when ego interferes with a person's expression (speech, for example) we have many ways to describe it – one might say, for instance, that the person has 'affected' speech or is a bit of a pseud. That is a sketch of our relationship with sound and the affective world.

↓

117. In classical music – when performing a work – one responds to the conditions in similar ways that one does with speech. The acoustical relations, the quality of the players, and the particular different sounds of their instruments are among the many dimensions that provide the conditions for a particular response. Part of one's work here (one's response) is to create a harmony between the different sounds instruments make. I do not just

mean between strings and the English horn, for instance, but between strings of the same kind such as the violins – each instrument sounds different, and each player, by virtue of being different in himself (impetuous, phlegmatic and so on), will respond in a unique way to his instrument's sound. This affects, for instance, how they use vibrato and so on. These things determine the tempo (or, rather, create it); to go in with an interpretation, even if one makes some concessions for the orchestral sound, ignores the musical landscape. Musicality – true musical expression – is nourished by developing sensitivity in response to the conditions one is faced with, and that, first and foremost, means abandoning ego and arrogance; ego and arrogance being personal reactions beyond that response, so to speak. It also means taking the time, as an individual, to come to terms with the conditions; this includes coming to terms with how each individual player or singer deals with them. An individual conductor's response to these things will, because of his nature, be different to another's. That is why concerts should not (and cannot properly) be made on one or two rehearsals.

118. If one sees somebody with headphones on and nodding, then one often thinks: "She is nodding along to music!" There is so much involved in such an exclamation being meaningful; so much presupposed to make such a statement factual. If I had never seen human beings before and existed outside their forms of life, there is so much I would need to learn before I could make such an explanation. Could I, for example, claim that people always "nod along" when certain sounds

are put into their ears (by headphones)? I would need to learn the role that music plays in a person's life; moreover, I would need to understand what music is, if I was to understand human life properly.[7] All these things are required if the statement "She is nodding along to music!" is to be factual. – It bears out that certain facts are facts only in virtue of the fact that we are human (with all that that means).

↓

119. Some might argue that a non-human may still be able to grasp this proposition as a fact, provided enough human psychological information was given to it. This might be so if a full understanding of others could be gained through psychological concepts (it might not be so if one needs to be human to understand such concepts properly). Parentheses notwithstanding, there are aspects of human life that one needs to be within, in order to understand, and in order for certain things to be facts. How do I understand "nodding along" in connection with music? How, as an alien for instance, could I recognise something as music? What else needs to be understood? And why do people sometimes "nod along" to music and at other times not?

120. Understanding through the psychological (and individuality): this hinges on the difference between a sense of agency and how one understands one's loved ones, friends, and people

[7] Obviously it is necessary that I do this, but it is not sufficient.

on the street. What is meant by a sense of agency? Essentially, what we have in common as human beings. So, we are rational to varying degrees, with such rationality being influenced by some of our other common characteristics such as anger, sadness, fear, rage, love, sentimentality, cynicism, pathos and so on. Sometimes we are neurotic and need psychiatric help.

↓

121. That such help is possible, rests on the understanding that we are all, to varying degrees, subject to such characteristics. But do we understand one another under such conception? Yes, insofar as psychological help is available, and yes insofar as we can impersonally understand the notion of individuality with regard to such characteristics. In other words, we can build conceptions of human agency from this. But is that how we actually understand each other? When a loved one dies, they are often spoken of as irreplaceable - it is a common way of speaking. Such people, I am sure, are not referring to the particular combination of psychological characteristics that their loved ones possessed. Indeed, if someone spoke of their mourned in this way – if they were to say, when questioned – that describing their lost loved one as unique and irreplaceable referred to a unique combination of psychological characteristics, we would think there was something very wrong about their relationship (and any profession of love that was made). That this is not so, illustrates that this is not the level (if that is the right word?) on which

we understand others in our various relationships that we have with them.[8] The oddness that we would feel in response to somebody (who had lost a loved one) saying that "unique and irreplaceable" was based on an understanding of the psychological characteristics of their mourned, reveals a conception of others as individuals that goes deeper than that based on a full understanding of others as unique combinations of psychological properties.

122. This thin conception of individuality is responsible for many of the attempts to objectify our behaviour towards one another, and how we understand that behaviour. Consider, for instance, phrases such as "person specification" and "behaviour management." There are complex reasons why these attempts are ill conceived but, in short, they are not based on a conception of individuality that asserts itself in the words "unique and irreplaceable"

123. The importance of narrative and appeal to art for understanding: It is odd that, until recently, philosophers have tended to ignore narrative as providing a fundamental dimension to our understanding. The philosopher Martha Nussbaum suggests that the fact that something is a story – that is, the form in which it is presented, can lead to greater philosophical understanding. She is, I think, advocating a version of the idea that the style in which something is presented cannot

[8] That in no way demeans the importance of psychology, but it does set limits around what it is capable of.

always be separated from what it is saying (that is, its content). Through this, she recognises the importance of narrative and how (and what) it can illuminate.

↓

124. Narrative, along with our other forms of art, is a part of human life. (so what?) – That it is so, means that it is a part of the conceptual landscape that marks our humanity (what we understand as human life). In other words, it plays a role in making us the creatures that we are (we are, if you like, creatures with narrative, hence the possibility of biography and autobiography). If we are to properly understand ourselves and others, we need to take seriously the kinds of understanding brought through narrative.

125. (Following Raimond Gaita) What is unthinkable is not necessarily so in a way that means (that) we can't think it; rather, it can mean something that cannot be seriously considered within an argument. In other words, that it cannot be understood as seriously counting for or against an argument. That is not to say, that such unthinkable things cannot be the result of clear, perfectly reasoned, argument. Indeed, that is very often what happens. We could reason, for instance, that in order to save money in the economy we should refuse healthcare to the homeless because they pay minimal tax but benefit from the services that are provided by those that do. What is unthinkable in that respect is interdependent with our perspective. This can take two forms: cultural and

individual. Cultural perspective defines and provides the limit for that culture. One culture, say that of the Anglo-American west, would – for example – find it unthinkable to leave their dead out for the vultures; the Parsees however, think it is honourable to do such a thing.

↓

126. What is unthinkable to one individual may very well be thinkable (that is, count seriously in an argument) to another within the same culture. This counts towards a conception of individual perspective. Examples of this can be found in things like the abortion debate; debate on whether we are sometimes required to kill people for the sake of the greater good and so on. Such a perspective is also partly internal to whether, for instance, an individual judges something to be art or not. Moreover, it conditions the kinds of thoughts people have as to the extent to which art can inform our understanding of ourselves and of others. Such perspectives can also be responsible for forms of "blindness"; sometimes one will be able – with help – to see another's perspective, at other times not. When we are blind, what we are blind to is undiscussable (in anything more than an abstract sense). That is how we recognise perspective as different from point of view. An example of a point of view might be the difference between how a doctor sees an ill person and how a layman sees them.

127. Meaning, consciousness, perspective and our relations with each other and other creatures:

Much of our conceptual content in relation to each of these things finds its meaning in resources similar to those that give conceptual content to artistic response. Artistic response nourishes certain concepts that would otherwise be much thinner. Similarly, the way we are moved by another person characterizes our response(s) to them and, as such, enriches our understanding of them. Such responses are related to forms of thought answerable to our sensitivity. So, how is it possible to distinguish between, for instance, a response that is meaningful in a way that is sentimental and one that is not? Firstly, a sentimental response can only be shown up by examples of what it is not. – That is not enough however, as conceptually, one needs to understand where the difference is located. Sometimes people can be sentimental in grief, and one way to distinguish between this, and grief that is not sentimental, is to say that the sentimental reaction is not a response that is appropriate to the nature of the relationship beforehand. The nature of the concepts we use in grief (and, in many ways, to understand others more generally) cannot be understood independently of the forms of life that give rise to them. Because the forms of thought that give rise to artistic response are not answerable to anything external, they cannot be eradicated by reason (only ignored). Cultures themselves are informed by such thought, but if the culture is one in which association, tone, style and so on, are treated as subjective superficialities - i.e. not to be taken seriously in any efforts to try to understand each other and our relationship with the world any better – then the concepts that are

nourished by taking such things seriously will become much thinner. We see this today with people talking about "behaviour management", "person's specification" the "family unit" and so on. The interdependence of art and culture means that the art will reflect the culture that produces it. I think "reflect" is the wrong word to use because art is not something that exists outside the culture, it is internal to it and, therefore, is a very important constituent of it; it is an aspect of the culture, a part of the character of the culture, and it sits next to language in terms of informing our understanding. It informs a dimension of our understanding that is beyond the reach of ordinary language; but there are still expressions outside language.

128. We are compassionate, and we can pity –such concepts go to inform the moral dimensions to our thinking and our individual responses. That thinking and those responses give rise to common practices within a culture. As' such, those responses and the similarities we see between them, go to inform the concepts that mark our ethical thought. Through that, compassion and pity are thought of as ethical responses. How we understand each other is, as such, mediated to a large extent, through the ethical. The similarity we see between such concepts –what nourishes the concept of what it means to be human – resides in the kinds of significance that others can have for us. The danger is when we estrange ourselves from the resources that nourish the depth in concepts such as pity, freedom, individuality, and compassion. One way in which this occurs (by far

the most prevalent) is to fail to recognize such responses as important in terms of nourishing a particular understanding of humanity. This can take many forms. Often, it is when we try to remove tone from our voice (whatever form that voice make take) in an effort to be "objective". The idea is that we should, in no way, let humanity in our thought influence our understanding, as it is thought that psychological factors act as an impediment to getting at the truth. Sometimes this is true – for example, when our sentimentality lets us believe that our pets can understand every word we say; in such a case, an aspect of our psychology has impaired proper thought, because there is a fact of the matter that exists wholly independently of our humanity (viz. that our pets do not possess the requisite cognitive capacities to understand human forms of life). But sometimes those very aspects of our lives are what is required, if we are to deepen our understanding of each other and deepen our understanding of the concept of a human being. That is one reason why narrative can be so important to our understanding. How we are affected in ways that are sometimes mysterious to us – for example when we lose a loved one – is an example of when we should not try to separate how we are affected by such a loss, from an understanding of what that person meant to us. That there is meaning in such things is what nourishes an understanding of seeing somebody as "fully human"; that is, seeing them as an intelligible object of somebody else's love. The questions that arise from this are: "How do we know that how we are affected is appropriate (consider the Princess Diana case)?"

and "How do we distinguish between when to separate how we are affected by something (ridding one's expression of tone if you like), and when we should not separate them?"

129. To look at the problem another way: (see Wittgenstein *Philosophical Investigations* 261-287). Descartes' problem: how do we know that there are other minds? Descartes is looking for a form of external justification of the kind once seeks in science; fact that exists independently of any individual, and those things that can be determined through valid deductive argument.

130. Following Wittgenstein, L 'PI' 243-315 and Gaita, R. 'ACH'. p.264: What justification is there that people feel as I do (feel pain or, pity, or grief, joy, anger, frustration, hatred etc.)? The answer to this question is often (wrongly) thought of as running something like this: I get my justification from seeing how other people behave; people exhibit behaviour that gives me the idea that they are joyous, in pain, angry and so on. But is this enough in terms of external justification? How can we determine for sure that others experience joy, anger, pain and so on, as I do? Is there enough for 'knowledge' here? Or do we merely suppose, basing our supposition on good grounds, weak grounds etc.? All this is based on the thought that others act in similar ways to the way I do. And we can – collectively – talk about our own behaviour in relation to our outward responses: "Yes, I was in pain when you hit me!" "My yell was one of joy!" and so on. However, how far can this be taken in terms of external justification? For that

form of justification, we would need to rid ourselves of preconceptions of expressiveness. Why? Essentially, because if we take someone's reaction as an expression of X, we already take it as an expression of consciousness. Even if I make a mistake in terms of interpreting an expression correctly – for example, I take a squeal for joy it when it is, in fact, pain, then I still am convinced that the squeal comes from a conscious being. The problem is that this is very much as we understand such expressions; as they are to us. What needs to happen for external justification to make sense in this way is – as Descartes would have liked – not to take the behaviour as anything. In other words, not to take it as expressing anything – and if we take it as not expressing anything, then what grounds do we have for certainty about the existence of other minds (or understanding such actions as behaviour at all)? If the behaviour is no longer expressive of something, then it is necessarily no longer behaviour that is similar to mine. And then it is no longer possible to say that I know others are angry, in pain, joyous, grief stricken, sad, and so on, because they are behaving like me when I'm in a particular state. And that means that what started out as an attempt to externally justify the existence of other minds has collapsed. One cannot externally justify my interpretation of someone's behaviour as expressive of X, even if they say it was an expression of X. After all, are they telling the truth? And how can one ascertain if they were not?

131. Yet, there is still the difference between someone who is angry and someone who behaves identically, but who is not actually angry. What then?

132. Psychology: there would be no psychology if we did not think people's behaviour expressive of something. The fact that we do recognise behaviour as expressive of different things, conditions the concepts we use in psychological assessments of people. It is not psychology that conditions such concepts, nor are such concepts externally justifiable. Thus psychological concepts do not come logically prior to our understanding of others. Those concepts are a condition of understanding humanity. Just as it is a general fact that femininity manifests itself more in women than in men, and masculinity more in men than in women, it does not follow that we should presuppose that all women exhibit femininity and all men masculinity. *The connection is not between being female and femininity but between our interacting responses that give rise to our understanding of expressions of femininity.* Being female does not logically precede understanding someone as feminine. That concept comes from the nature of our responses to particular expressions found in individuals, and the general fact arises from femininity being found more in women than in men. That we understand peoples' behaviour as expressive, provides us with the possibility of psychological understanding; there are then, general facts that arise from our expressions and responses to them; those provide

the possibility for psychotherapy and other treatments of similar orders.

133. The psychological is brought about, therefore, by the significance that people have for one another; the kind of significance they have. That is what determines the character of our behaviour and our understanding of it as expressive, and the notion of the concepts we use in psychological criticism.

134. The concept of freedom, for instance, is in part nourished by our relationship with the natural world. This is where the importance of our bond with the natural world lies, and why we need to remain sensitive to its beauty. That beauty can nourish our pity, euphoria, sadness freedom and so on. One can feel pity for one aspect of nature pitted against another, whether it be a leopard chasing a gazelle or an insect drowning in the water.

135. Education and forms of thought in which form and content cannot be separated from content: I'm not speaking in this case, about the broadened understanding of humanity that a developed sensitivity to art can bring. I'm talking about the need to expand the idea of what we consider to be legitimate education. I'm not talking about teaching art or music in schools (though I think in many cases these things are woefully under taught and/or taught in the wrong ways). There are those who complain about poor education, but they don't look at how education is given. There is of course, the debate over whether children are examined too much, or whether we need to teach

in a way that digresses a little from just being trained to pass exams. I'm in sympathy with this but, again, that is not what I'm getting at. The point is that, so often, we take seriously the product of thought in which cognitive and non-cognitive content cannot be separated; for example, the significance of others (in love and grief for instance), and how that transforms our understanding of them making us answerable to moral concepts. Similarly, we find certain concepts such as freedom, nourished by the natural world (or at least sometimes so). My point is, one needs to take seriously those forms of thought that can educate us, whether it be scientific knowledge or how to live. [9] But of course, not everyone takes the same forms of thought seriously. – This is the heart of the issue: how do we educate where there are no criteria, but still definite forms of understanding - understanding that can bring certainty? It is difficult: some people will be deaf to some forms of thought. Sometimes such thoughts go to determine what matters –do we then consider what matters to be wholly arbitrary? Of course we do not. In some cases then, even those who passionately profess benefits of education will be deaf to the things that, for education, are very important.

136. Natural history is important in education because it brings us into contact with the things that can

[9] " Standing by my rights", for instance, is not enough to show why something is right or wrong. The abuse of a right does not, in itself, show the wrong of what is done.

nourish concepts that would either be much thinner or absent altogether. For example the magic which occurs when a wild creature deigns to trust you, or when you see something amazing in the natural world. Just like Gaita's conception of freedom being nourished by the landscape in Australia, so such things not only bring us closer to the natural world, but nourish concepts such as freedom and wonder. These things, often determine for us what is amazing. Lying in a field full of buttercups on a warm summer day listening to the song of the Skylark can be, if one lets it, one of the most remarkable experiences. As such, it means something and, once it has entered the realm of meaning, it becomes conceptually relevant to human life. But such things can only work on us in these ways if we give them time to do so; that is the nature of what it takes to achieve that form of awareness. Estranging oneself from that awareness by not taking time, means that many of the ways we find depth of meaning will become severely atrophied. Rushing past will relegate these things, either to meaningless aspects of our lives or, for instance, to "nice views." In that respect an interest in natural history becomes just like an interest in stamp collecting, or trains, or beer, shopping or bell ringing. That is, it is just an interest no matter how much one happens to know about it. All of these things can nourish us, can absorb us is something else, (that is the nature of interests after all) but they do not demand the time that it takes to be touched by the possibility of understanding oneself as a mortal creature, a being, an animal. One doesn't need to know much about the natural world to wonder at it and to be

touched by it. Nevertheless, an understanding of the creatures that share the earth with us can only serve to enhance those things. I do not mean to be critical of anyone's interests, only critical of the thinking that an appreciation of the natural world is no more than an interest that cannot nourish us conceptually, any more than other interests such as trainspotting. I am critical of the attitude: "You like natural history, I like shopping, someone else may like stamp collecting, it's just a matter of preference which one you like, and you cannot see that because you think your interest is the best." – That is an example of when one thinks of personal preference as resulting in psychological distortion.

137. To look at an a priori conception of rights based on the fact that we all have a psychology: That is, at bottom, what gives each of us an obligation to uphold the rights of ourselves and others. They are, if you like, the consequence of our psychological sameness.

↓

138. In this respect, there is almost an obligation to celebrate many of our differences. Not all differences should be celebrated and the thought is that those that should not, conflict with rights. Our thoughts and feelings are part of the commonality produced by our psychology – that we have these in varying combinations can be given as a strong reason to see individuality as based in the celebration of difference. Because psychology, and the practice of psychotherapy is a condition of understanding common humanity, it follows that

the differences we display through our different psychologies should be celebrated and seen as a part of humanity also. So we have, on different levels, individuality and sameness (rights are thought to respect both aspects). Much emphasis, in terms of rights, is focused on the individual because, through a study of psychology, we are able to empathise with peoples' differences even if we do not fully understand them. As such we understand peoples' differences as a fundamental aspect of humanity and, as such, internal to what we understand as a right. In other words, rights must take in this aspect of humanity, since not to do so, is to ignore a person's humanity; not see them as one of us. Thus, when we ignore the differences (tangible ones) between two people, we run the risk of transgressing a human right. That is why we think a celebration of difference so important.[10] But is it as fundamental to a conception of others as we think? Is there anything else that does this work that we pass over?

↓

139. Recap of psychological underpinning of rights and Kantian conception: fundamental differences are that the Kantian conception adapts rationality to the peculiarities of its subject matter – that is, its psychological characteristics. It is however, rationality divorced from such characteristics that

[10] Is there a contradiction between this widely held attitude, and that which says we should exclude masculinity and femininity from our thinking if we're to avoid sexism?

provides us with our moral duty. By contrast, the a priori conception of rights advanced by the "common psychology" view sees such psychology to be necessary in order for such rights to be a priori true.

140. Grief at the loss of a loved one is internal to an understanding of them as unique and irreplaceable in a way which transcends a celebration of difference. The question is whether that conception of individuality is extraneous to our moral understanding. After all, everyone grieves and pities (if they do not, it is often the case that they are diagnosed with some form of mental illness). Part of the grief and pity, for instance, in the Jamie Mizen case, revolves around how he died; that he was killed. That grief and pity is partly internal to the sense of wrong done, and relies on a conception of individuality that transcends celebration of difference. But surely that would have been the same with any one –we would have pitied just the same had it been someone else. So, the thought goes, we need to concentrate on the universality of such things, if we are to understand the demands of morality. Surely, what is important is that any human being in such circumstances will be treated in a similar way. That is obviously true, but it is not the universality of that truth which informs the moral dimension of what occurred to Jamie Mizen. If that were so, then our pity and grief would be extraneous to what informs our moral answerability to others. It is the uniqueness and irreplaceability of each one of us – informed by, among other things, love and friendship – that

conditions the concept of individuality, that transcends a celebration of difference. It is our understanding of others, rooted in that concept which informs the terribleness that any human being is murdered; but we only understand *that* because of the fundamental particular importance of each individual. So it is not –as Gaita puts it – that we grieve for a 'representative of humanity' (Gaita, R. 'G&E' p.148). We grieve an individual in a way that runs far deeper than his individuating characteristics. That is how love can transform such understanding. And our understanding of others as intelligible objects of love, pity and grief makes us subject to pity. In other words, pity and love are internal to understanding individuality in such a way.

↓

141. A good part of our understanding of humanity is informed by individuality of this kind. Part of the difficulty is that feelings of grief, love, guilt and so on, in connection with (for instance) the Mizen case, are considered as particular psychological dimensions – that is, as personal reactions. And there is nothing "more general" (so to speak) in such reactions. What we encounter in rights and the language of rights, is something that is supposed to show the universality of wrong done, divorced from any psychological dimensions, to yield a neutrality of description (that is perceived as objective). What the language of rights tries to do is to give credence to such concepts – give them an ethical dimension – but without the personal accents of pity or love.

↓

142. Put another way: the language of rights attempts to avoid a charge that such psychological reactions are – through their personal nature – of limited value in a universal conception of right and wrong. After all, two people may react very differently to the same thing. So rights attempt to plant objectivity in universality by avoiding individual response. And the language attempts to root out personal emotive response through a neutrality of description that is devoid of pity or love; there can be nothing more general in such reactions because of our individual psychological make-up.

143. The authority of the universality of rights does not come from examples of humanity; the wrong in transgressing of rights does not come from wronging an example of humanity. It comes from an understanding of what we do to particular human beings through our understanding of them as fundamentally individual.

↓

144. The authority of rights does not come from humanity as a whole with each person being a representative of that humanity. The universality that we find in rights comes from an understanding of a person as profoundly individual –that understanding is an aspect of how we understand humanity. It gives sense to the expression: "seeing somebody as fully human." The understanding of rights as moral authority is

nourished by that understanding. Rights in themselves cannot be relied upon to yield the moral worth of their transgression. Though of course, if we did rely on them in such a way, the results would often be similar or identical. – And of course people will say that it is good to universalize as much of morality as we can in such ways. Furthermore, many will be convinced that it is reason that has allowed them to pin morality to something objective. They will see this as a triumph over those that argue, and claim to be able to demonstrate, through showing the subjectivity of individual emotional response, that morality is subjective – subject to the whims of particular individuals. Rights, it will be said, uphold benchmarks of morality to which the subjective responses of each of us are accountable.

145. When we talk about objectivity in everyday speech, we do not worry about its meaning; its meaning is clear to us. We use it in one of the many ways it can be used.

146. It is only when we try to strictly define what we mean by objective that we run into trouble. If we think about many of the sensible ways we use the phrase "I know that......." Or "I'm sure that....." and so on - what often happens when we think about what it means to be objective, is that the meaning of the word becomes subject to intellectual distortion.

147. Concepts such as love, pain, hatred, evil, jealousy and so on, are defined by the roles that they play

in our lives. Look at the difference in logic between this and the logic of abstracting them from their roles in our practices in order to try to define them (set limits to their meaning rather than our practices shaping meaning). When one yells in pain, that is an expression of pain rather than a description of it.

148. So what is the difference between relying solely on rights to guide our moral behaviour, and being attentive to the individuality of others, if the results of each are substantially the same? An analogy would be someone who is motivated to expose another person's criminal activity on the grounds that he is of a different racial background. What would be the difference between that and reporting the crime because you are an honest citizen? Surely the difference doesn't matter? (If the results were substantially different then this argument would not be relevant). If the system of rights gives exactly the same results in terms of behaviour, then it is surely extraneous (and precious) to say that we should be attentive to the profound individuality of the other in any way beyond observing that each of us has equal rights?

149. Dignity and love: The desperation to retain the dignity of a loved one in death is internal to an understanding of their individuality. To perceive the dignity of the natural world is internal to a love of it, and informs what we understand as violations of nature. Our sense of violation is, in part, conditioned by a sense of its dignity born through how we cherish it. Yet it would be crass to ask why we do not accord the same kind of

treatment (rights etc.) that we do to humanity, if the claim is that it is love that transforms understanding of individuality. – It is a love that attends to its subject matter requiring a particular kind of sensitivity. – There are different kinds of love also: love of parents, friends, relatives, romantic love, love of a pet and so on, each of which play a role in shaping our understanding of our relationships with each other and the natural world. A love of the natural world can bring with it the possibility of its violation, but that can never be so with a love of shopping. Neither can one talk of retaining the dignity of shopping, but one can talk in this way about the natural world. That is part of why a life filled with acquisition is a life estranged from the resources that go to inform a love of, and interest in, the welfare of the world.

150. How we use language expresses the differences we see between things as well as the similarities. (people seem to notice the similarities much more than the differences – why all the attempts to universalize?)

151. And the way we speak about events – those taking part and so on – and the sorts of emphasis we put on these things, often shed light on our thinking; that is, how we understand certain concepts (consider, for instance, the first woman in the British army to be killed in Afghanistan)

152. And such emphases – how we notice etc. – condition the concepts we use in our reasoning. There are cases where the emphasis we put on something (for example, the news and comment

that followed the first female soldier to be killed in Afghanistan) contradicts what we actually say about the concepts in the abstract as it were. – For instance, men and women have equal opportunity and, through what motivated that situation, opportunity should be commented on in exactly the same way. Yet that is not so – and that, in itself, is one of the things that is internal to our understanding of differences between men and women. On the one hand we say that both should be treated alike, but in comment – not always in the content of the comment but in, for instance, the amount of time given over to it – we reveal the contradiction. Much less comment was given over to the first British male soldier killed in Afghanistan.

153. Through our use of language in the form of poetry and prose, we express the meaning of forms of understanding describing the forms of life that we lead. In such things is the acknowledgement of humanity – the acknowledgement of what it means to be human. One cannot dismiss such forms as irrelevant in terms of how we conceive of each other. If they were truly meaningless in that respect, there would be no possibility of understanding fostered by them.

154. When we learn the language it is not the achievement of having done this – the achievement of pronouncing and spelling words correctly and an understanding their meaning – that is important. Language is part of the apparatus that is interdependent with the way we live; it is a part of the mechanism that makes such

ways of living possible. One might say, distinctively human ways. As such, language (what that means) could not exist without a form of life of which it is a part.

↓

155. Take the sentences: "This sentence does not make sense!" and "There is a circle. Its length is 3 centimetres and its width is 2 centimetres." (*Ludwig Wittgenstein and The Vienna Circle* quoted in Monk, R. 'TDOG' p.285.) In these two cases, both sentences make grammatical sense (as it were) but in another way they are nonsense. In the first, the grammatical construction of the sentence is juxtaposed with its actual meaning. So you might be disposed to say that it makes sense insofar as the grammar is correct but does not make sense insofar as it is non–sense. It cannot be sensible by virtue of that juxtaposition. Something similar can be said about the second sentence: the proposition makes sense but a circle can never have such dimensions as in the proposition; so we either have to accept it as nonsense, or make further inquiry to establish the misunderstanding of the word 'circle.'

↓

156. Whatever the case, such sentences reveal something very important about language and its relationship with reason. They are not of a kind that can be proved true or false and, in that sense, they are not externally justifiable. Nothing in the sentence: "This sentence does not make sense." can be externally justified or, through reason, be

understood as true or false. So, what is the relationship with reason? We have two features: when language and reason act as one, and (2) where they are separated from each other. Sense, therefore, is determined by the character of its subject matter (a form of life of which language is a part) rather than independently of it. That is to say, the difference between truth and falsity, and sense and non-sense is *not* answerable to the same thing (reason). (reason itself is something abstract)

↓

157. So what is the case when we speak non-sense in the form of "This sentence does not make sense." or "This circle is three centimetres by two centimetres."? It is where the form of life no longer nourishes the language; the language has, in such instances, become divorced from the form of life which gives it sense. It no longer participates in the form of life that gave it sense (and nourished our understanding of it as a *language*). Without a form of life to support it, it would cease to be a language. So: "This sentence does not make sense" is only understandable as non- sense because it's out on a limb, as it were, from the form of life that provided the landscape for the development of language. It is, so to speak, borrowed from language. There could not be a language made up of non-sense because there could be no form of life to support it (only madness and one cannot create a language from that).

↓

158. One could not have a language born from madness because madness lacks criteria – a madman may employ his own private criteria but it could never be developed into a community (one cannot have a community of madness with its own culture and laws etc.). One may think the practices of a community to be madness (Parsees leaving their dead out for the vultures; using magic where we would use science etc.) but that is a very different thing altogether. It involves a very different (and suspect) use of the word madness. One could not describe the people of those communities as mad.

↓

159. Private criteria in the world of the madman are no criteria at all because following or obeying criteria is a public practice, requiring rationality. The madman may think he is following criteria that no one else can, but something of that order is actually internal to a form of madness. Criteria cannot be essentially private. That is why a form of life – a way of living – cannot be formed from madness. (thinking one is obeying criteria is different from actually obeying them cf. Wittgenstein's private language argument)

160. What of the view that everything is externally justifiable – it's just a question of becoming sophisticated enough to find the answers to provide the justification. This is a view with faith; one might call it a scientistic position. And one could, as such, call such a belief a form of worship.

↓

161. If we take moral concepts such as goodness, evil, hatred, jealousy, love, anger, euphoria etc.; they are forms of understanding with a certain kind of answerability to our practices. They occupy a place in our practices and condition how we understand such practices. That is to say, they do not refer to anything in terms of an object. Indeed, they are not a label attached to a thing; rather, they have a meaning reflected in, and defined by, our ways of living. What does this mean? – Someone who believes that everything is externally justifiable might argue that such concepts are only justifiable against the subjectivity of the person thinking them – there can be no one standard for that very reason. Therefore, we cannot realise any more about them. Not anything, at least, that admits of authentic universal explanation. On that conception we cannot know that another person is angry, in love, in pain, filled with hatred and so on. So, we are left with the idea that our sensations/behaviour is what such words refer to (and, as such, obtain their conceptual status) and that we can only infer from another's behaviour that they feel as we do. This reference to behaviour and so on, is the external justification that is being looked for, although it is not satisfactory. It is not satisfactory because it can make no reference to (and therefore justify as the same) the actual sensations or feeling. The sensation, on this conception is again, as Wittgenstein said, 'not a something but not a nothing either.' (Wittgenstein, L. PI:304). So, any external justification based on this thinking will be

unsatisfactory: on the one hand it is only the behaviour that informs the meaning of the word (and, therefore, the concept), but that is not enough, since we understand it is informed by sensation, which seems then to have no place in the meaning of what we are saying when we use the words. Does what we feel when we are wronged or when we pity, get angry, or love, drop out altogether when we talk of such things? And whatever it is that only I have access to, cannot be the meaning either, since no one else can refer to it. So where?

↓

162. What we mean when we talk in such ways *is* (found) in the differences and similarities between these things, which are shown up in our forms of life. What it means to be wronged is not something that only the person feeling wronged can know to its full extent, neither can such meaning be understood just from another's behaviour; it is a reflection of a part of how we understand each other, and what that understanding amounts to in a form of life. It is not the case that an aspect of the meaning of what it means to wrong someone, or what it means to say that another is angry or jealous, can never be wholly understood because an element of it can only be accessed in its entirety by the person experiencing it. − For then, if our experiences were all so different we could never understand fully what others talk about. But then: of what use would language be? And, more importantly, why have words developed that it is impossible to

access the meaning of? Indeed, would it be possible to invent a language in which it was impossible to fully understand the meanings of the words used? I do not think so. Those sensations and ways of understanding (pity, pain, grief, jealousy, love, anger and so on) do not, in themselves, *refer* to anything. There is no place for the individual sensations/experiences; nor do they refer to the behaviour of individuals. They get their meaning from the role they play in our form of life and, as such, can never be justified independently of humanity.

163. The words occupy a place in a form of life and we understand fully what we are saying when we use them; that is why there cannot be a language in which the speakers of it do not understand fully what they are saying. (That would not be so if a speaker knew that whoever he was talking to could never understand fully what he was saying. How could a language develop this way?). Certainly, the form of life would be very different –what we understand as a language would be very different from a "language" in a form of life in which the speakers of it do not understand fully what they are saying. For in using such a "language" one would already be aware of an inherent lack of meaning.

164. And if one doesn't know the full meanings of some of the words, or all the words one is applying, how can one be sure one has applied them correctly?

165. Although the arts are often funded quite well from various political organizations, they generally include only those considered to be "accessible" with some degree of commercial value. The thought is, presumably, that the more accessible art is, the more people it is going to bring into contact with it. And commercial value allows it to fit uncontroversially into the current political/economic environment. There is however, good reason why art should remain entirely independent of either of these factors. Naturally, some of the arts are going to be more accessible and commercially viable than others, but that provides no reason to treat them any differently from those that are not.

↓

166. To say that we should promote the accessible/commercial arts over those that are not either of these things, is like saying we should only use those parts of language that are popular – or at least, pay them the most attention. Other forms should not be taken with the same degree of seriousness. So is it the most common thoughts/expressions that should be treated with the most seriousness? But some expressions are rare, precisely because of the sorts of conditions that give rise to them; the sort of seriousness that they demand.

↓

167. Artistic expressions take many forms and each form (if it is genuine) expresses something (a

form of thought) that cannot be made explicit through any other form. It becomes absurd to suggest that we tie forms of human expression to commercial value or accessibility. (Would we do that with ordinary language?) Obviously, much art needs funding, but there needs to be an informed understanding of a kind that sees it (art) as a fundamental meaningful human expression. In that sense, there should be an obligation to fund it, and not just those aspects that prove commercially successful and/or the most accessible.

168. The irrationality of relativism: the non-sense of relativism in terms of adding anything substantial to moral thought. Relativism is, essentially, the view that all moral views, no matter how deeply held are, at bottom, all relative. The thought is that they are a creation of humanity; that there is nothing thoroughly independent of humanity (external to it) that provides justification for our moral beliefs. They are, if you like, entirely subjective.

↓

169. None of that makes murder less meaningful, even if one grants, rightly, that moral thought has no justification independent of humanity. Nor does it explain why we should treat it with any less seriousness. That our sense of the importance of humanity centres on each individual – when, for instance, we pity those who mourn the victims of knife crime –rather than just any human being, informs a fundamental dimension of the concept of humanity. Interdependent with that concept are

those things that mark our morality. So where is the sense in saying: "It's all just relative?" The idea is that because such meaning is not external to humanity, its authority is somewhat compromised. I see no reason to believe this. Indeed, anything we value is answerable to the same charge; we value science and art, but in neither case is that value independent of humanity. So what does such a qualification amount to? What does "it's all just relative" do apart from, perhaps, encouraging us (psychologically) to take value less seriously?[11]

↓

170. But is there an argument rooted in such an assertion that we should take what we value less seriously? Should we believe, if we think "objectively", that because "it's all relative" the difference in seriousness between killing a cat and a child is nowhere near as serious as our subjective value system would have us believe? Put another way: should our certainty – or judgement – of the dreadfulness of what was done to Jamie Mizen or Frank MaGarahan as being worse than the killing of a pet be undermined because (ultimately) our moral values "are all just relative? Indeed, if it is all just relative then there need (logically) be no difference in terribleness or in kind between such things.

↓

[11] That would be a very good example of when individual psychological response acts as an impediment to proper understanding.

171. If such a (relativist) qualification is not making an argument that we should take the demands of ethics less seriously, then it makes no sense to say it. If it is making such an argument, it needs to show what it is about our moral certainty (that, for instance, the killing of animals for food is very different from the dreadfulness of the murder of a human being) that should be reformed in its light.

↓

172. The relativist might say – as Sartre did – that our morality is an invention. The philosopher Mackie said much the same. In their different ways, they both said that morality is a creation. That this is not so is *not* because morality is independent of humanity; morality is not independent of humanity. It is because the concept of creation finds its form within a realm of meaning. It does not find its form in the practice of creating a realm of meaning.

173. Psychological impossibility, moral impossibility and the certainty that one just cannot do something independent of psychological impossibility and general ideas of morality: there are two big distinctions that need to be made. The first is when one finds something psychologically impossible – for example, that one cannot eat prawns because one is squeamish or, more relevantly, when one cannot do something that could be mistaken for moral impossibility such as finishing off an animal with a spade when one has accidentally maimed it in a road accident. Psychological impossibility of this kind can be

confused with moral impossibility because it is also possible that one could find it morally impossible to do such a thing.[12] The distinction is quite clear when one recognises certain psychological impossibilities with no moral dimensions (such as the inability to eat prawns).

↓

174. The second, is between general ideas of moral practices and individual impossibilities. The Parsees leave their dead out for the vultures; there is no way I would have done that to my father but that does not mean I condemn what the Parsees do as morally wrong. Nor should I.[13]

↓

175. Sir Peter Scott saw the natural world in a different light after his return from war. It became impossible for him to kill wild creatures where previously he had shot them for sport. He did not suddenly become aware of some ethical issue that he had previously been unaware of, neither was it that he found it psychologically impossible (say, because he had developed an aversion to blood). Scott's perception of wetland landscape, and the natural world more generally, changed and it became impossible for him to shoot wildfowl as

[12] One might say that all impossibility in this form is psychological. In one way that is true but it does nothing unless one is arguing that there is no such thing as moral impossibility, only psychological impossibility.

[13] But such possibilities and impossibilities structure, and are structured by, the realm of meaning in which such impossibility reveals itself.

he had done before. The spirit in which he beheld the natural world had changed. That impossibility need not be a moral one; and it certainly does not imply that those who continue to shoot wildfowl do not understand what they're doing. The certainty involved in such impossibility is of a certain kind dependent on the spirit that makes such shooting impossible. If Scott had resumed shooting wildfowl, it would have been because he no longer saw the natural world in the same spirit that made such shooting impossible.

176. The same thing can be said – and Simone Weil says it (in her essay 'Human Personality' – about the spirit of justice. Spirit is a tricky idea – two people can perpetrate identical actions but in completely different spirits. One person might kill a squirrel with glee because a disease threatens an entire colony of other squirrels. Another person might do it with a heavy heart. What is the difference? Both are, after all, ridding the colony of a problem that threatens a whole species. Yet one person may see tragedy in the killing of a wild creature whilst another may not. Nevertheless, the same result has been achieved so what does it matter? – The rare colony of squirrels has been saved. Something similar might be said about those with a deep love of the natural world, and those who advocate building eco-towns in order to demonstrate they are doing something positive about the environment.

↓

177. There is a certain meaning in one action that is absent in the other. Seeing the meaning of something as Scott did, relies on the spirit in which he understood it and, thus, perceived it. That realization extends beyond what we understand as morality (or ethical responsibility towards the planet) but it is, nonetheless, entrenched in a realm of meaning interdependent with the structure of morality. Morality is, as it were, dependent on such examples

178. Different people will see different things in Scott's example; some might see a moral absolute in his example; others may care for wild creatures with a fierce compassion but still be able to kill them. It all depends on the spirit in which one perceives the natural world. Some may see beauty in the natural world through its giving itself to us, others may see it as something in which killing should take place only when it is absolutely unavoidable. The point is, that such examples condition the concepts we use in our moral reasoning; provided one has authoritative examples, one can respond to the same moral problems differently. Hence, the personal in ethics. That is the distinction between general ideas of moral practice and individual moral necessity (but one could not exist without the other)

179. Sometimes, as individuals and/or as cultures, we find the actions of others repulsive and morally unthinkable; consider the process of leaving one's dead out for the vultures. Yet, it is often the very things that we find ethically repulsive which

nourish the moral concepts/practices of that culture. Nevertheless, there is still a substantial conception of right and wrong and moral practice in each culture. And there are the concepts of good and evil. These concepts are present in many radically different forms of life/ways of living, some of which will be beyond the understanding of people from outside that way of life. Nonetheless, within each of these forms of life will exist the possibility of moral purity (with all that such a concept relies on in relation to other moral concepts) and of living a moral life. What all forms of life have in common is the existence of a moral culture (whatever form it may take).

180. That a morally pure life – a life understood as such through its relationship with other moral dimensions within a culture – can be of a kind that is unthinkable for those in a different culture, shows that the concepts that support moral cultures cannot be understood (as such) independently of the thoughts and practices that give rise to them. Yet there remains a moral dimension to every culture.

181. The way one tries to extract form from content in the grip of a conception of proper thought that has, at its core, the idea that form must always be separated from content (if we are to be objective and get at the truth) is, itself, a form of self censorship with the capacity to alter perspective.

182. That every culture has a moral dimension (even if the practices associated with it are considered dreadful by other cultures) shows ethical thought

to be a central component of all forms of human living. Morality, as such, is common to all (and each of us is answerable to it) even if its modes of practice are radically diverse.

↓

183. What each form of life has in common is the centrality of the human in moral thought. With the Parsees, an individual is properly honoured in death if his corpse is left for the vultures. Yet this would constitute a criminal offence if an individual from an Anglo-American background did the same. One can imagine the expressions of incredulity (if you like, impossibility): "How could he do that to his own father?" Yet central to each of these expressions is the individual, construed as unique and irreplaceable; the honour bestowed on them in death (and that we believe it is honour) is a manifestation of that understanding. That informs the thought that humanity is ultimately precious. Even cultures that reject the importance of each individual asserting – rather – that it is humanity itself that is precious, is ultimately still established in individuality. For otherwise, what would lend it its preciousness?

184. The complex responses of people sometimes seem inconsistent, and can be a reflection of their mode of living and the kinds of difficulties they encounter. This is related to the authority with which different people of different cultures speak about different things. And that is related to

perspective and our understanding of it. Cf. Frazer's *Golden Bough*.

185. Sometimes a person (or a people) direct a complex and, seemingly, inconsistent range of responses towards people from other cultures. But the accusation of inconsistency only looks bad if one tries to understand their responses independently of the form of life that they participate in. Often such responses reflect a particular form of life and relationships with others. Their responses are shaped by the difficulties they encounter, and can be the sign of truth towards a way of living.

↓

186. Such ways of living – and the sorts of responses they condition – provide an authority with which to speak about them. That is what gives nourishment to the description of two people (or peoples) as "worlds apart." The authority with which they speak, is of a kind that is conditioned by their form of life, how others respond to them, and how they respond to others. When that is incomprehensible to someone from a very different background, one can say that two such people are worlds apart. And, of course, what is unthinkable to each is often a substantial component – if not the defining component –of such differences, as is what counts for them. These kinds of differences need not just apply to those from radically different cultures. Often, those who live in (substantially) the same culture – certainly the same society – find themselves

facing such difficulties (that is part of the answer as to why there is no such thing as responsibility to society). See Rhees, R. 'Responsibility to Society' in *Without Answers*. Routledge and Kegan Paul Ltd. London. 1969.

↓

187. Not everyone, therefore, can speak with the same authority about, for instance, being working class, or what it means to be a black man trying to carve a career in a predominantly white society, even if the society in which both occur is having that conversation with itself. Such differences can also have a profound effect on justice or, rather, what it means to be just. A rich man may believe he treats a working class man well, but the working class man may not understand it that way. The idea of justice stems from an authority to speak (the right to speak, if you like) about dimensions of his form of life nourished by what is unthinkable and what counts in such a way of living. An individual who is not embedded in such a culture has his authority to speak about it compromised. That is not to say that he should not speak about it, but it is to say that if his words are to carry an authority, they must be tempered by an understanding of the distance between himself and the person(s) he is speaking about. – An example of what I mean can be observed in the way people from different forms of life speak to each other: a working class man may address his peers in a particular colloquial fashion but he would not have the authority to address someone from a different background with the colloquial expressions that

Philosophical Notes

they use with each other. Similarly – it is quite unusual for a white man to address a black man with a colloquial expression that only a black man would normally use towards another black man. Sometimes friends have unique "nicknames" for each other that would be offensive if another used them. The same thing goes for all sorts of ways of living: people with terminal illnesses, disabled people and so on. Those kinds of difficulties have given rise to political correctness which, in some cases is well justified. In others it is not. When it is not, it becomes the making of a difference rather than the acknowledgement of a difference in authority. Our irritation with some forms of political correctness is symptomatic of an understanding of that conceptual difference.

188. Sometimes we use the word "right" when we should really use the word "authority." Consider: "You don't have the right to speak in the way you have about X" – Often, that should be: "You don't have the authority to speak..." "Right" is not synonymous with "authority." "Authority" does not mean "entitled"

↓

189. There is, of course, another important dimension to political correctness: it is what one feels one can and cannot legitimately say without causing offence. The things that are legitimate targets for political correctness are a consequence of our perspective. They are a part of what gives form to the culture. Perspective itself is nourished by – or rather – is interdependent with, what we find

impossible to take seriously in an argument; impossible that is, if we are called to think seriously and soberly. Of course, we can still think such things in the abstract – as examples of technique in arguments – or, perhaps, to highlight what counts as legitimate persuasion beyond strictly valid argument.

↓

190. Following an abstract argument to its logical conclusion and to say that that compels you to take it seriously, is part of what gives philosophers a bad name. Indeed, sometimes they go so far that others (non philosophers) have a legitimate case to call them cranks. Part of the reason philosophers argue in such a way is because they believe that to get at the truth, one needs to separate the form in which something is put from its content; as such, the thought is that one should be legitimately persuaded by (strictly) valid argument even if its conclusions are horrible or bizarre (that I can't prove the existence of the external world, for instance). Though pretty much all philosophers don't take seriously the radically sceptical position of the external world being unprovable, they virtually all ignore why one doesn't; even though, as strictly valid, the argument is of the same kind as those who say we should take seriously the conclusion of arguments to moral nihilism. That sort of attitude is, essentially, a form of thoughtless scientism; one might say the worship of a particular way of thinking. To some, it is unthinkable that there is any other way of thinking. Any thinking that does not conform to

that model will be seen as just the result of failing human thought (perhaps psychological impediment, or poor epistemological ability).

191. The unthinkable: is essentially that which we cannot consider seriously in an argument (even if it is in the form of an argument); we won't take it as something that should be seriously considered. As such, those aspects that should not be seriously considered, in part, condition a proper conception of reasoned argument. An argument cannot, therefore, be considered an argument (for or against something) if it does not pay attention to what is genuinely beyond serious consideration. The character of an argument determines whether or not the argument should count (be seriously considered) in a way that is interdependent with the character of our thought; that is generally so, as well as in particular cases. There are many valid arguments with true premises, the conclusions of which are inescapable, yet impossible to accept; and just as many that we can accept. And the character of our thought is determined by its subject matter and the kind of critical concepts to which it is answerable; that, in part, serves to determine the kind of seriousness we are called to in argument, as well as the character of the argument.

↓

192. What we find unthinkable changes with how we understand our subject matter. But that is not to say that what we put beyond serious consideration is a product of psychological difficulty; a

difficulty in accepting the conclusions of certain arguments. But of course, there are arguments that we do not consider seriously for precisely those reasons; often they are the ones that we feel we cannot make because of the pressures of political correctness. Sometimes it is because we feel that any engagement with the subject matter is, for example, crude or vulgar (perhaps attitudes to sex might, for some people, be undiscussable). And there is a fundamental conceptual difference here: to distinguish between the genuinely unthinkable and certain forms of social conditioning or psychological difficulty.

193. What makes certain things unthinkable for us – that is, as not occupying a serious place in our considerations – is not reason or what is answerable to it, but forms of thought associated with different kinds of understanding (forms that give rise, for instance, to the concept of satire which, in turn, nourishes the concept of absurdity); moral understanding is one such form. Moral impediment only becomes nothing more than psychological impossibility if nothing is beyond serious consideration and everything is separable in terms of a form and content. If nothing was truly beyond consideration, then it would not be possible to see a conceptual difference between the thought that Nelson Mandela was a terrorist and deserved to be incarcerated for terrorism, and the thought that the system of apartheid he was fighting against was justified.

↓

194. That is the difference between taboo and something that is fundamentally beyond consideration on pain of – for example – what it means to soberly and seriously assess the moral life, or perhaps, one's own moral seriousness.

↓

195. Nothing is beyond argument only if nothing is beyond serious consideration. That means that nothing is beyond argument only if one treats argument as authentic if it excludes the possibility of truth being expressed in ways in which form and content cannot be separated.

↓

196. To exclude that possibility is to say that those things that we feel we cannot seriously consider in an argument are only psychological or, in wider contexts, the consequences of social conditioning. That, in turn, profoundly affects what it means to exercise sound judgement.

↓

197. The conceptual difference, therefore, between taboo and what can (and cannot) be seriously considered in an argument, is located in our conception of reason and argument. That is to say, it is located in what it is for something to count properly as an argument, rather than as something that is located outside authentic argument. If we excluded the possibility of forms of thought in which form and content cannot be separated, we not only exclude the possibility of that thought

properly informing the conceptual landscape (as in the difference between taboo (those aspects which are legitimate targets for political correctness) and what cannot be seriously considered in argument), we also impair the possibility of proper judgment. This is so because, by thinking that what is unthinkable is only ever a consequence of psychological impossibility or social conditioning, it makes it impossible to recognise a proper conceptual difference between what is taboo and what is genuinely unthinkable. And, if that is so, it gives us the idea that we should/ought to question everything if we wish to think properly. That being the case, what is the difference between the thought that Nelson Mandela was a terrorist, and the thought that the system of apartheid he was fighting against was justified? - Nothing. Nothing, because it is then impossible to say that one is taboo and the other not; it is impossible, for instance, to distinguish between an opposition to an argument because of one's social conditioning, and an argument that is (or should be) genuinely beyond consideration, because both are outside what is often thought to be a proper conception of valid argument.

↓

198. Judgment is undermined on this conception because one can be legitimately persuaded by any valid argument with true premises. If one is unafraid to seriously question anything, then it is impossible to distinguish between what is genuinely beyond serious consideration and what are merely deeply entrenched psychological impediments. One cannot

then oppose the conclusion of a strict argument, even if its conclusions are vile, because that vileness can only be construed as something psychological; it may not be pleasant to push such boundaries, but ultimately those boundaries are formed from psychological and social factors – or so the thought goes. But nothing separates good from bad judgment in this respect (or, at least, fundamentally separates them). For good and bad judgment to exist in genuine forms, one needs the ability to discern between those arguments that we should consider seriously and those arguments that we should not. Such aspects are fundamental to an understanding of individual and cultural perspective.

↓

199. There are however, other examples of poor judgment such as certain jokes made by comedians. Of course, pushing the boundaries is not always thinking the unthinkable or inviting one to think the unthinkable. Sometimes, boundaries can be pushed by transgressing taboos – sometimes this causes offence; confusingly, the kinds of responses created by pushing boundaries against the unthinkable and pushing the boundaries against taboos are often very similar or identical.

↓

200. When such judgment is undermined, other difficulties arise. (In normal ways of speaking and living, we include forms of thought in which form and content cannot be separated and, as such, do not ascribe all the things we feel we cannot

seriously consider to psychological difficulty. It is only when we try to define those concepts that are nourished by forms of thought in which form and content cannot be separated that the difficulties arise; such motivation comes from trying to be "objective"; from the belief that the tone in which something is uttered should always be removed in order to get at the truth. Neutrality of tone is thought to be the best way to get at the truth)

↓

201. The thought that nothing is beyond consideration encourages us to challenge everything because everything we consider to be unthinkable can be collapsed into the form of the psychological. Doing that, undermines the notion of common sense, and the judgments that characterize it because, often, such common sense and judgment find their authority in what we find unthinkable. As forms of the psychological, they can be legitimately challenged. As such, confidence in common sense and the judgements that characterize it is shattered. Frequently, this results in attempts to standardise responses (to avoid a weakness of an individual using "common sense" which is understood as far too subjective) and modes of practice, even if they sometimes feel as though they contradict what ought to be done. We need look no further than the practice of box ticking to grasp the sort of thing I mean.

202. Of course, standardisation often comes about from observing particular samples of methods and responses, and deciding what works best. This

eliminates the need for judgement (even though good judgment would see to it that most results came out that particular way anyhow, but it would avoid the problem of exceptions). The problem is that it does not allow for exceptional cases in which such methods and responses are inadequate. When this happens, it is often the case that a review is conducted which concludes that the original standardisation was good but inadequate in a particular case –a caveat is brought in to deal with such cases from then on. Each time something goes wrong, a review is conducted, a caveat introduced, and so on. (That is why, in Anglo-American culture, there is the tendency to believe that training and education amount to the same thing.) The idea is to eliminate the need to use "common sense." The problem is, if we try to eliminate common sense and its characterising judgments in all aspects of our lives, we might be considered mad. There would be no *good* reason not to take Descartes' thoughts, about what we can know about the external world, seriously. Similarly, judgment about whether we could trust others would rest on an understanding of the probability of being betrayed in all the different aspects of life with which we interact with each other. This in itself, would not be judgment, just simple mathematical calculation evaluating the probability of betrayal of some kind. So if, for example, my mother and I get on well, I would calculate that there is a low probability that she will try to undermine my chances of pursuing the career of my choice by clandestinely indicating to potential employers that I was unsuitable for a position. Yet if I actually thought like this in terms

of my relationship with her and with others (perhaps my friends), I would be considered at the very least paranoid and, possibly, mad. That this is so, testifies to the role that judgment and common sense play in concepts such as paranoia and madness.

↓

203. It might be remarked that the probability of a mother or father (in a loving relationship with their offspring) acting in this way is so low that we just don't think about it because it's not intellectually possible for us to do so. Thus, our confidence in this respect is – the thought continues – related directly to probability. If we thought about it, we would realise that our certainty is directly related to the probability of events occurring.

204. The problem is, if that is so, we should find our certainty varying in accordance with the probability of events occurring. Thus, if we think hard about these things, we should be able to develop different degrees of certainty relating to our assessment of probability. Yet, it is a general state of affairs that almost all parents do not act in this way (and that is important). That said, there is still the tiny chance that one's parents might act this way. Nevertheless, I would be considered at least paranoid if I said that, improbable though it is, I need to bear in mind the probability that suggests there is at least a chance of this. Thus, there is a clear epistemological difference between understanding on a probabilistic level and

understanding the concepts we use to assess each other in a lucid manner. That epistemological difference (how we understand) is marked by the sane and the insane.

↓

205. That we do not think like this is not indicative that we don't have the capacity to keep such calculations at the front of our minds all of the time; rather, it is indicative of a form of life that has, at its core, sanity and madness. Certain things are – unless one is mad – beyond our capacity to take seriously. And it is that, above all else, which distinguishes the sane that from the insane.

206. A lack of confidence in one's own judgment can lead to standardisation (and the faults that occur through working that way) or, in severe cases, the collapse of one's sanity. (Often though, it is ambivalence)

207. Sometimes, philosophers raise questions based on issues that should be ruled out of consideration – that is, arguments that cannot (or should not) be taken seriously; there is often no answer of a kind that will satisfy them (that is, an answer based on the idea that one should go wherever the argument leads) because there is nothing in such a conception of argument that leaves room for the dimension of the unthinkable.

208. Humour: what is funny? There are various different ways to look at this. Firstly, there are types of humour (that can be character conferring) such as the Benny Hill kind, then there are,

perhaps, those who appreciate silly humour exemplified in jokes such as: "Surely you can't be serious?" "I am serious – and don't call me Shirley." These forms of humour are inoffensive, though they may not appeal to everyone. Then there is satire –if you like, humour with a point. Sometimes this can be found offensive. Then there is "pushing the boundaries" humour, and it is this that I want to discuss. There are many instances of such humour being found offensive. The question I want to discuss is the difference between offence caused by breaking a taboo, and offence caused by finding something funny which is symptomatic of a failure to understand what finding such a thing funny actually means. In other words, finding something funny that one really ought not to if one had a proper grasp of the subject matter. The problem, as I have already sketched, is that the external character of the offence caused is often similar in both cases. So, "pushing the boundaries" humour can have two dimensions: 1. Where it exposes a taboo (and can cause offence in so doing). 2. Where the humour – the fact that it is something the comedian deems to be humourous – is symptomatic of a failure to grasp properly the full reality of its subject matter or target. Examples of this might take the form of treating homosexuals and paedophiles in similar ways. Some do say that one should not be afraid to push such boundaries – claiming that it is just a psychological dimension that prevents us from finding humour in such things. But where does one draw the line? Surely, one could then say that humour could be found in any event. – And, of course, it could be, but only if one's grasp of the

subject matter was inadequate. By collapsing all offensive boundary-pushing humour into a species of psychological impediment, one cannot then distinguish between, say, offence caused by talk of sex (often a taboo subject) and offence caused by something that is radically unsettling because it fails to grasp what is so dreadful about finding it funny. That is the same thing as collapsing the genuinely unthinkable (brought about through an understanding if its subject matter) into a species of the psychological. Such humour often rests on the notion that if one separates the form in which something is presented to us from its actual content, then "if you think about it" what is so awful, dissolves. – So it must be (the thought continues) a case of psychological impediment. Taking that kind of argument to its logical conclusion, one could say that the rape of a young child is less bad than the rape of an adult, as the child does not have the cognitive capacity, or the conceptual apparatus, to realise what is being done to it in the same way as an adult does. Something similar could be said about intelligent and less intelligent people. – One could say these things only if we dismiss much of what nourishes the concept of a "child." The concept of a child, and what it means to be a child, relies on so much more than rational capacities and how we think about that; it relies on what it means to be a child, and that is nourished by our seeing authoritative examples of a mother's love for her child, how a child exists free of so many of the responsibilities that characterize maturity, a child's trust in its parents and other adults. All these things – and more –we see and learn through witnessing

authoritative examples that nourish our understanding and, as such, our sense of what is unthinkable; moreover, they nourish the sense of the evil of those who do think the unthinkable. We are moved by such examples, and in such examples, form cannot be separated from content. We can wonder at a mother's love for her own flesh and blood, and that demonstrates the sacredness that one human being can have for another. But, more than that, it is the spirit in the thought of another human being as someone's own flesh and blood that deepens, without limit, understanding of what it means to be human. That is wholly different from trying to separate this out from treating each other with unconditional respect because we are rational creatures. Similarly, it might be argued that we are empathising with a mother speaking of her offspring as her own flesh and blood. But we do not feel as the mother does towards her child; indeed, we may have thin grounds for feeling this way if we have never had children. Neither do we feel like the child if they have been raped (or like the mother if her own flesh and blood has been raped). Thus, it cannot be empathy that informs our understanding of the wrong done either. Our responses are conditioned by our understanding of what it means for a human being to suffer in particular ways. Justifying one's pity and compassion by saying that all human beings are ends in themselves, or that we feel as they do, fails to the point of offence to those towards whom our justifications are directed. Imagine if I said to the mother, having never had a similar experience myself," I know how you feel." Yet,

not having that experience in no way undermines my understanding of wrong done, or my pity for the victim. In any event, the forms that our thoughts take about other human beings – through, among other things, seeing them as intelligible object of another's love –are of a kind that cannot be separated into thoughts about individual character (or psychological characteristics); they are of a kind that can see each human being as unique and irreplaceable through the possibility of them being an intelligible object of someone's love. Even the most dreadful evil-doers –those who deny humanity in another, through for instance, rape or child abuse or murder –are owed full acknowledgement of their humanity. Their evilness can only be understood from a perspective conditioned by a conception of each one of us as unique and irreplaceable and, through that, bound together in humanity. It is only from that perspective that we can deliver justice properly. Those forms of thought that condition our understanding of humanity are also, then, what condition what is unthinkable for us and, as such, our perspective. They also allow a distinction between that and what is taboo. So it can then become clear that finding something funny can be symptomatic of a failure to grasp its subject matter properly, rather than just a willingness to push past a psychological barrier.

209. The spirit in which something is done can be the difference in meaning, even if the results of what is done are exactly the same as a person who

perpetrated the same actions in a different spirit or in no spirit at all.

210. How the existence of general facts leads to standardization: it is a fact that virtually all X result in Y, therefore we need to standardise procedure to ensure Y as an outcome. Such procedures can become very sophisticated, particularly when exceptional cases occur that demand a review in procedure to deal with them, so they are no longer exceptional. The idea, of course, being that there is something objective we can refer to which avoids relying on the subjectivity of our own judgment (for example, the demands of Ofsted in terms of procedural records, reducing everyone to a type – "person specification", and other box ticking procedures). So, to a large extent, such procedures are related to the general fact that gives rise to them, and that is important. However, it is a mistake to think that there is a necessary connection between general facts of this kind and procedures (and it is mistaken to believe that there should be). It is our various (infinite) forms of living that give rise to general facts, and the concepts that characterize our lives. The general facts do not exist independently of our ways of living. And because of that, there will always be exceptional cases – cases which procedures based on general facts are incapable of addressing properly. Yet, it is because such general facts exist that we have procedures at all; and we need procedure. And, of course, sometimes when we are unsure about how to proceed, appeal to general facts about ways of living can prove indispensable. Yet they can also

prove destructive: destructive if they are considered a priori true or, if uncomfortable with that, logically prior to how we (should) understand the world. That is, as it were, to understand the relationship between procedure and general facts the wrong way round. Obvious manifestations of this occur in the realm of how we understand gender: it is an important general fact that femininity is found more in women than in men (and vice versa). That is why each is tied to its physical sexual category. But it is not legitimate to precondition our responses to men and women on such grounds, since to do that ignores the conditions through which femininity and masculinity arise at all. The same can be said about reacting the other way round: that is, to remove all thoughts about masculinity and femininity from our responses towards each other. In each case, sexism is the result, or at least, a neglect of a dimension of a person's individuality. The necessary connection is not between being female and femininity, but between our practices –our responses to one another –and the concept. The general fact arises from femininity most often manifesting itself in women (as such, it is tied to the physical sexual category of female).

↓

211. What constitutes good education, and the difference between that and training, is related directly to standardisation through (or by) general fact. To grasp a procedure, we need only the relevant training, and that is related directly to procedures derived from such general facts. As

such, we have recourse to training and procedures avoiding the possibility of error inherent in our own judgment. – And, of course, training to grasp such procedures can be very sophisticated. Sophisticated in terms of specialisms such as law, medical training and so on, as well as, more generally, what are termed "life skills." Some might say that learning life skills is, in fact, one's education, and one's training is what one specializes in. One can train to be a teacher and how successful one is, after one has graduated, is assessed by a recognised monitoring body such as Ofsted. Success in such cases is measured against results and how well one has adapted the recognized procedures that are seen as delivering the best results. (Such procedures, it should be pointed out, are extremely sophisticated and allow for different abilities, and different methods to teach different abilities; nonetheless, they are still procedures based on (standardisations) general facts about how we learn (what are the best ways to get us to learn and so on)).

↓

212. The point of such standardisation is, as I said, an attempt to provide "objective" standards because there is a lack of confidence in (subjective) judgment. This cuts a number of ways in terms of the advantages and disadvantages it can bring in particular cases (I am, at the moment, looking to the education system for my examples). An advantage is that someone whose judgment is poor can still deliver a reasonable standard of teaching through following procedures.

A disadvantage is that those who have excellent judgment are apt to feel restricted in terms of what they are able to achieve and deliver in their teaching. This however, is not the real heart of the problem.

↓

213. It is when we try to rule out the use of judgment or, at least, individual judgment outside the parameters of procedures that have been developed from a general fact, or general facts, that we run into difficulties. It is our judgement (and its development) that has given rise to general facts from which procedures have been derived. To undermine the relevance of judgment in our learning will, apart from anything else, radically change the nature of many of the general facts to which it gives rise. More importantly however, it estranges us from the resources that allow us to distinguish the genuinely unthinkable from the things we find psychologically difficult to think, because it does not allow for the legitimacy of forms of thought in which form and content cannot be separated, and which nourish the possibility of judgement. By excluding that dimension of our life from serious consideration, we set limits around our education; indeed, it then becomes difficult to see a conceptual difference between education and training (something that is being increasingly shown up in the government's attitude towards education, with its targets and increasingly frequent testing). And because of that, it becomes increasingly difficult to see a conceptual difference between the thought that

Nelson Mandela was a terrorist and the thought that the system of apartheid he was fighting against was justified; similarly, it becomes difficult to see a clear difference between the thought that victims of genocide deserve what was done to them and the thought that survivors have have subsequently exploited such horrors for their own ends. Both (if we exclude thoughts and their attendant expressions in which form and content cannot be separated) become only psychological impediments because there is nothing to distinguish between what is just psychological difficulty (remembering that Nelson Mandela was a terrorist, or that the victims of genocide have, on occasion, subsequently exploited their suffering for their own ends) and what is genuinely beyond consideration (that victims of genocide deserved what was done to them)

↓

214. The relationship between judgment, what we legitimately and illegitimately rule in and out of consideration, the relationship between that and mere psychological impediment, our understanding of that difference and what informs it; and, finally, what constitutes a proper understanding of legitimate argument. Understanding of all this cannot be achieved through standardisation from general facts, because it is our practices that give rise to such facts. And we can be trained in procedures derived from such facts but it limits our education – what it means to receive and possess an education – because an education is what gives us the capacity

for sound judgement, and understanding of what one can legitimately rule in and out of consideration. This is related to broadening one's understanding, to reflecting on what it means to live a good life, what an understanding of each other as fully human, or others as fully our equals really amounts to, legitimate and illegitimate censorship, justice and so on.

↓

215. A conflict between this and education as it is currently being structured in Anglo-American culture, is shown up through the irritation of many teachers in both public and private sectors. That irritation is symptomatic of an understanding of standardisation not being the best way to teach and educate. Indeed, standardisation based on general fact ignores the way such general facts arise and, as such, rules out a considerable dimension; that dimension is what brings about such general facts. To then consider it – how we respond to one another, how the multitude of our expressions informs and brings about general facts, as well as a conceptual richness –peripheral to sober and serious assessment of many of our practices, estranges us from the resources we need to understand the general facts in their proper light. Thoughts about them (and the concepts that marks such thoughts) become much thinner or vanish altogether.

↓

216. Such dimensions include understanding the spirit in which something is done, and how that can be

of fundamental importance to understanding the moral worth, or content, of that action. In our education both teaching and learning suffers; and the learners subsequently become tomorrow's teachers. The teaching can now only attend to (properly at least) what it takes to pass examinations, and if those examinations are frequent this leaves very little time for other forms of learning or, better put, learning beyond training that comprises an education. For in education, some things that we are capable of learning necessarily take time to achieve through periods of reflecting on their meaning.

↓

217. If teachers are primarily instructed to get their students through tests, and if in their teaching they are instructed to treat as peripheral, those dimensions that I have suggested go to inform general facts, then those who are taught by such teachers – some of whom are will go on to become teachers themselves – will not be given access to the resources that make those peripheral dimensions seem important. Gradually one can see how perspective on life and education changes; how what we are willing to seriously rule in and out of consideration changes as a consequence of how we understand the relevance of particular kinds of expressions and thoughts.

↓

218. Often, the spirit in which something is done has a profound effect upon its meaning (even if the result is the same as someone who had acted in a

different spirit or in no spirit is all). And the spirit in which something is done is often reflected in the expression used to describe it. But in a quest for objectivity, and because science delivers such fine results by separating fact from the humanity of a thought (separating form from content), it is thought that this needs to be done in all cases (that this *kind* of thinking needs to be adhered to) if we are to understand things as they really are. So, it is thought that we need to extract the tone in which a thought is expressed from what it is actually saying; the actual spirit that is reflected in the tone is considered peripheral to proper understanding. I want to say that this gets things hopelessly the wrong way round, and that paying close attention to the spirit in which something is done – and to its attendant expressions – is essential to a proper understanding of many of the thoughts that we have about each other, and what it takes to assess them soberly in relation to our practices. Many, I think, would believe that this is just common sense, and that many of the judgements we make about others, characterize it. But if we are not prepared to accept that the form that many of our expressions take is internal to their meaning, then we cannot subsequently distinguish between what is merely psychologically difficult to think, from what is genuinely unthinkable, because the unthinkable is collapsed into a species of the psychological.

↓

219. That then means that we can no longer take seriously the form that such expressions take in

the concepts that we use to assess each other; there cannot be a fundamental meaning to them that nourishes and supports particular concepts (e.g. "saint", "grace "– more obviously: "God", "religiousness" &c). Increasingly, Anglo-American culture is becoming conceptually estranged from those aspects of our lives in which the spirit in which something is done is of fundamental importance. It is shown up in our expressions that are used easily within the culture to describe aspects of human life: "behaviour management," "persons specification," "collateral damage" (as used when describing killing of innocent civilians in war); all these terms represent forms of simplification. It is a form of simplification that aspires to neutrality of description, so as to separate form from content.

↓

220. Much of a culture is defined by what is unthinkable within it and, as we push towards simplification of many of the "spiritual" (that is, the spirit in which we do things) dimensions of our lives, what becomes unthinkable and thinkable will change (although not in any sense algorithmically), and reduce the nature and richness of many of our concepts. That too, is internal to cultural perspective and interdependent with what we find unthinkable. After that, it becomes natural to speak of the meaning of life, what it means to be good, what it means to have a proper education, what it means to live well, as just things that are done in leisure time, or at university, or by people with not enough to do,

rather than getting down to the "proper business" of the world – proper business that is free of the incumbencies of subjectivity. That is also a dimension of our culture. And if we cannot see the harm in living this way because our conceptual landscape has been stripped of those dimensions of which I have been speaking, then what does it matter if we live this way? There is no actual –or direct – answer to this; one can only say that an enormous amount of meaning that life can have has dropped away. And certain expressions redolent of the spirit in which things were done have gone dead on us because such ways of thinking and understanding no longer live for us.

221. Certainly – with reference to the above –what it means to have an education will become almost (conceptually) indistinguishable from training. Hence the emphasis we are seeing on testing, and teaching to pass exams, rather than allowing teachers to use their own judgment in how they teach. Part of the reason for that is the poor judgement shown by some teachers – those, for example, that advocated the idea that children teach themselves and choose their own curriculum. Of course, that has its problems too now, as the products of such a way of thinking (culture) enter the world as teachers; they will not (and do not) have the capacity to exercise the kind of judgment that would make them fine educators, as they have never come into contact with the dimensions of thought that allows for the possibility of fine judgment or (in some and by no means all cases) the commonsense approach. Obviously, common sense and good judgment do

not always go hand in hand, and that is partly what is internal to the concept of fine judgment. Common sense may not always be good sense, and it is judgment that allows us to recognise when that is so. Similarly, standardisation by general fact (because of how general facts arise) is not always the best way to proceed. By excluding the possibility of individual judgment by such standardisation we alienate ourselves from what it took for such a general fact to arise at all. So where is the good judgment of maintaining the procedures based on the general facts, if what it took for them to arise has dropped away? – There is little, which is why, more and more, we are losing those dimensions of our lives that provide a richness to our understanding of what it means to be kind, and just, in the spirit of charity (one might say, living a human life). Then, of course, we cannot be left to our own devices in our teaching and learning, because we will not have the judgment to make us aware of what counts as a good standard of teaching; we will have lost what it took for that general fact (or facts) to arise at all. Thus, we enter into circularity: we have to stick to the procedures derived from standardisation by general fact in order to maintain standards, but it is that very thing (that very way of assessing our practices) which has undermined our capacity to do it on our own; to exercise sound, independent judgement on our own. That is the fundamental component of our education, but it is being undermined by such a perspective. Moreover that is the fundamental ingredient that allows for a sharp conceptual difference between education and training.

222. "Knowledge transfer coordinator" seems to be used more and more as a term for teacher. This is an example of an attempt to eradicate tone, while trying to maintain the importance of the role of a teaching job in the eyes of others. Of course, in previous times, the importance of being a teacher – in the form of providing someone with an education and an understanding of what that means – was understood; and the requirement to change the terminology would have seemed unthinkable (and, as such, absurd).

223. Part of what is internal to some concepts necessarily takes time to achieve, e.g. coming to understand what it means to wrong someone by reflecting on how one's thoughts and/or actions have the meaning they do. Such understanding cannot be grasped through theories learnt from textbooks.[14]

224. Earlier I said: sometimes philosophers raise questions based on issues that should be ruled out of consideration – that is, arguments that cannot (or should not) be taken seriously; there is often no answer of the kind that will satisfy them (that is, an answer based on the idea that one should go wherever the argument leads) because there is nothing in such a conception of argument that leaves room for the dimension of the unthinkable. One cannot, as it were, argue on the same playing field as those who refuse to rule anything out of consideration.

[14] Why should we accept these theories as correct? Do they show the meaning of what we do?

225. Part of the reason for this is a scientistic form of thinking - a form of thinking that is at its most rigorous when questioning hypotheses that it is presented with. In the scientific idiom this is the kind of thinking that has achieved the finest results. And if we consider that there is only one kind of thinking – one method – that gets to the truth, then this must be it. There can be no conception of the unthinkable beyond the entertaining of an hypothesis that is obviously false; trying to advance science on the foundation of a false hypothesis. But scientific progress relies on its results, and the methods through which they are achieved, as beyond any particular human being. In other words, science relies on the independence of its results from subjective interference; the possible interference of human subjectivity in its methods. That is part of the reason why no hypothesis should be free from questioning. It is impersonal.

↓

226. That is why many philosophers (and others) say that, in order to be truly a proper thinker, one should not fear to think anything (nothing should be unthinkable); one should question everything to see if it stands up. This is what I mean by scientistic thinking. Thoughtless scientism is the expression I will use to describe a blank acceptance of this kind of thinking as always the right kind when thinking critically.

↓

Philosophical Notes

227. It might be the case that certain kinds of thinking and understanding are non scientific, but that does not mean they are automatically less worthy (as is often thought) or that, through such thought, lucidity is not possible.

↓

228. There is then the difficulty of how one argues in this respect: internal to the idea of a serious ethical thinker is that they will put certain things beyond serious consideration – that murder is a terrible wrong, for instance. The demands of scientific thought mean we cannot put anything beyond serious consideration (i.e. that each hypothesis must be seriously considered before one can accept or reject it and proceed). Therefore, a person who doesn't accept the possibility of proper understanding being achieved through anything other than scientific thinking, will find it impossible to find his feet with a person who argues that lucidity can be grasped through the forms of thought (in which form and content cannot be separated) we encounter in music and poetry, for example.

↓

229. Further difficulty arises because there can be no such things as ethical facts; one cannot talk in terms of moral facts. But for someone in the grip of thoughtless scientism this is enough to say that ethical thought cannot really advance our understanding. And it is also enough for them to say that ethical arguments are just disagreements

between different subjectivities. Consequentialism often arises from this way of thinking.

230. Can we tie a conception of reasoned argument that includes the idea of the unthinkable to logic? Is to exclude the possibility that the conclusions of some perfectly valid arguments (with correct premises) are beyond serious consideration, to exclude a certain kind of logical impossibility? (If not, then what can be said about logic?) Is there, for instance, a dimension of logic that makes it impossible to accept the conclusion that Descartes advanced (through valid argument with correct premises), that we can know nothing for certain about the external world? Is that impossibility a form of logical impossibility? As such, is there also a form of logical *possibility* associated with such a conception of reasoned argument? Language, as a way of living, provides us with the grounds upon which we can make (logical) distinctions because of the role it plays in our sense of meaning and understanding. In one sense logic is defined by language – the role of language conditions our sense of meaning.

231. Behavioural models are for automatons, not human beings: they set limits around what we can understand in terms of our responses to one another. We can, according to such models, respond in exactly the same way to automatons as we do to humans (Turing test)[15] – there can be

[15] This revolves around Alan Turing's imitation game. The basic idea is as follows.: an average human being engages in various linguistic activities with another human and a machine; each is isolated from the other. The machine has been designed to react in ways humans

emotional models (automatons can "grieve"), cognitive models (automatons can separate emotions from facts) and so on. Indeed, automatons can be programmed to respond in all sorts of ways to levels of sophistication that humans use in everyday life. But do we, as human beings, *really* respond to an automaton as we do other humans? After all, as Raimond Gaita points out, one turns off an automaton when one goes to the shops or takes a holiday (for instance). And the reason for that might be to save on our electricity bill, for example. And even if an inexpensive permanent power source had been invented, the thought that they could be turned off if something went wrong with them is enough, I think, to say that we do not respond to them as to human beings; and enough too, to say that models of behaviour (based on patterns of psychology) in no way represent the essence of how we understand one another as unique and irreplaceable. Presumably, if we are talking 'models of behaviour', the fact that one can turn off an automaton should not matter. Of course, we sleep, and robots (or automatons) could go into an equivalent "power down" mode – but would that really be an equivalent? We go to sleep; robots shut down. Could a robot really understand the tiredness or jadedness brought about by soul destroying work? In the end, every model sets

do. If the human judge cannot tell the difference between the machine and the human, the machine has passed the test. Arguments surround this idea in terms of how "human" we can make machines; how mastering understanding of psychological response and sophisticated computer technology can lead us to create something that we cannot distinguish from a human being.

limitations; that is the nature of a model, it excludes things. Moreover, the model itself cannot change without becoming a different model (perhaps one could have a series of models?). But the concepts that mark our behaviour – that allow us to identify certain forms of it – are themselves conditioned by the fact that we find the behaviour of other beings expressive.[16] Such psychological concepts do not, therefore, come prior to our understanding of the behaviour of others; rather, they are a product of understanding that behaviour as expressive (or understanding action as behaviour at all). Can one, for instance, believe that the behavioural model, or a particular kind of intelligence (as psychologists are prone to categorise them), can show in an automaton the difference in meaning between binding someone's wounds to heal them, and performing the same actions with a tenderness brought about by an understanding of suffering; of what it means to have fallen into that condition; to have become helpless and vulnerable. Or, if one's friend or relative has lost everything that gives her life dignity – if they have become mentally ill and are now living out their days in a mental hospital – can an automaton be programmed to see the full depth of that person's degradation in a way that moves them to respond with tenderness? Can they see the suffering (and what it means to suffer in such a way) of a person who believes that their life has been wasted by their mental illness? Is there a model for that? So when we try to

[16] If we did not find the action expressive/meaningful in some way we would not, I think, even consider it as behaviour.

understand others' behaviour by referring to models, I would suggest that, at best, they yield a very thin understanding of that person (perhaps something inductive). How can one then *properly* respond to them? One only needs models because a reliance on general facts has eroded judgment to the point where one does not have the resources necessary (sensitivity) to realise that every relationship can deepen without limit and that every response is more than just an algorithmic one; and that this realization – rather than models - conditions what it means to see the full humanity in another. For someone with behavioural problems, responding to them through models, in order to get them to respond in a certain way, is not only to set limits on what can be achieved, it is also to fail to respond to them as someone – as a human being with dignity and grace. Once one has been estranged from those resources then one can rely on nothing but models with all that that entails. It seems to me that one of the reasons such models now have such prominence is because they relieve people from rising to the demands that others place on them; one can just use a model(s) to determine one's response instead.

232. Can automatons with their sophisticated behavioural models, understand psychological concepts such as femininity? Surely, in each case, their response will be based on a concept that comes prior to understanding that kind of expressiveness. That is also how behavioural models are formulated –the concept comes first, before an understanding of that kind of behaviour. It is as if the concept exists prior

to any form of expressiveness; that it is part of the fabric of the universe so to speak.

233. Is chivalry sexist? This is an interesting question. It begs for a definition of the term chivalry. The only way one can do that, I think, is to look at it in terms of what actions may count as chivalrous. The problem here is that one is always going to encounter cases in which one sees similar actions in similar cases that are not deemed to be chivalrous, or that where we are inclined to say that such actions are not chivalrous, we should actually count them as such because the actions are of a similar kind in similar circumstances. The debate will then centre on, for example, which party is put at an advantage, or whether one party considers the other as less well equipped to tackle particular tasks and, thus, assists them (irrespective of whether they desire help or not). In this latter case, such actions might be considered patronising and as such, sexist if directed from male to female or vice versa. Of course, that need not be so, but one then has the difficulty of establishing the motives of each party. If I hold open the door for a woman at a station, say, am I doing so because I think she will find it more difficult to open doors than I can, or because I have a vague hope that we might strike up a conversation leading to other things, or just because I'm trying to be helpful? She need never know any of these reasons, and may or may not judge me to be sexist. I may just be trying to be helpful, yet receive the retort, "I am perfectly capable of holding my own doors thank you!" Obviously, it becomes clear that, in this case, she

thinks I'm sexist. So, perhaps, all such acts are intrinsically sexist? - Maybe those who don't object are just allowing themselves to be "walked over" by society?

↓

234. Well, I think the character of this debate is in the wrong area; indeed, I think the question of whether chivalry is sexist should be put very differently, if asked at all. Historically, chivalrous acts (chivalry) have not been understood as gender specific. In other words, historically, a chivalrous act could be made from one man to another man or man to woman (without any implications of sexual orientation). In more recent times it has been understood as much more gender specific – actions counting as chivalrous because they are directed from a man towards a woman. We do not, generally at least, conceive of women as being chivalrous. That this is so (popularly at least), I think, fans the flames of the idea that it is sexist. But this is looking at the problem in the wrong place as it were; in the wrong way.

↓

235. It would be better to think of it – the idea of chivalry that is – as partly constitutive of the relationships between men and women. Another way of putting it might be to say that it is partly constitutive of the relationship between masculinity and femininity. It in no way follows that chivalry is sexist, though it does not rule out counterfeit forms of it – counterfeit forms that may be so, precisely because they are sexist. To

make this clear I need to look again at masculinity and femininity and how they relate to individuality.

↓

236. When our responses are honest and free of presuppositions about the person we are talking to (for example, free from our ideas that this person is a woman and therefore should be responded to in a certain way) then our responses reflect the individuality of that person. When one's responses are free of presuppositions, we do not respond to the man or woman and then to the individual; we respond to a person who happens to be a man or a woman. Awareness of masculinity and femininity arises through our interacting responses with one another in such ways (and gives rise to the formation of the concepts). It is only when we allow thoughts of masculinity and femininity to precede appreciation of a person's individuality that we become sexist. In other words, we precondition our responses to men and women on the grounds of the general fact that femininity is found more in women and masculinity more in men.[17] But it is not the case that being female means one is feminine or being male, masculine. Awareness of masculinity and femininity arises from the way we respond to one another and, through that, become critically aware of different forms of behaviour and expressiveness. The connection is not between being female and

[17] That is why each is tied to its respective physical sexual category (and named as such).

femininity, or being male and masculinity; it is between (the meaning of) our responses and the concepts through which we characterize them.

↓

237. When one's responses are honest, one doesn't allow the fact that someone is a man or a woman to precede anything else about them – one responds to *them* as an individual. They may indeed be very masculine or feminine and that is a fundamental aspect of their individuality, and one that affects our responses to them and theirs to ours. Thus, it is also sexist (and this is something which is often overlooked) to remove all thoughts about masculinity and femininity from our responses. In this case, we allow the idea that treating men and women (indeed, people generally) equally, relies on responding to them in exactly the same way – a way that, in order to be fair, needs to be devoid of concessions in response to either masculinity or femininity. That is also a neglect of individuality and is just like allowing the fact that someone is a man or a woman to precede anything else about them (except, in this case, we presuppose that we should ignore certain aspects of their character). We should allow the possibility of masculinity and femininity to arise in *both* sexes if we wish to be sincere about being sensitive to the individuality of others. There is no unconditional connection between being male and masculine or female and feminine. It is important to see the difference between the existence of a general fact and a necessary connection.

↓

238. Chivalry is partly constitutive of the relationship between masculinity and femininity (not necessarily men and women), insofar as genuine chivalrous response is defined by the responses between certain kinds of expressiveness (that we often characterize as masculinity and femininity). The manifestation of genuine masculinity and femininity provides the conceptual landscape for acts of chivalry; it allows for the possibility of the concept, and need not result in anyone's individuality being compromised.

↓

239. Of course there are occasions (and they are not uncommon) when there is sexism in what may appear (or even claimed) to be chivalry. Such counterfeit instances arise from a denial of the individuality of the persons involved; the fact that someone is a man or a woman precedes anything else about them in terms of one's response. And of course, one is then condescending to them. But chivalry need not be the denial of a person's individuality if it responds without presupposition(s) to their expressiveness – when it is honest, it partly characterizes the relationship between masculinity and femininity and, as such, one of the many (infinite) forms of relationships human beings are capable of having with one another.

240. Early in 2009 on the BBC radio four programme "Any Questions", the panel were asked: which

words or phrases would you most like to see scrapped in the English language? Two of the answers were quite revealing. The philosopher Roger Scruton said that he would like to see the phrase "social inclusion" abolished and replaced with "kindness." Another member of the panel – whose name escapes me (I'll call him X) – said that he would not like to see any word or phrase scrapped, as they all lend richness to the English language. I found myself agreeing with both Scruton and X. I agreed with X because of what language is – namely a practice that is part of our way of living, providing our lives with meaning in a way that nothing else does; because language – its expressions and phrases – belong to a particular way of living. That is why, unless one is familiar with a language and at home with the way of life to which it belongs, one cannot gain much from its poetry (even if one has a basic smattering of the language in question) because the relationship between the language and the form of life – or culture – of which that language is a part, is incomplete.[18] One is not immersed in that culture and, as such, one cannot realise the richness of its possibilities and see that richness in its language. A complete relationship would be defined, at least in part, by one's capacity to see the depth of meaning in such poems in relation to the rest of the culture.[19] However, I agreed with

[18] One could say that certain poems might help towards familiarising us with the way of life from which they came – that may well be so, but I shall not talk about that here.

[19] It would not be good enough to say that one understood the poetry to be an important part of the culture.

Scruton in a different way, but for the same reason (that is, that language – meaning and expression – are intimately bound up with a particular form of life). I agreed with him because the very fact that there exists the phrase "social inclusion" is indicative of a way of living that shows a contrast between it and kindness. Surely the notion of social inclusion could be discarded (dissolved altogether) if we exercised a greater degree of kindness towards one other. Social inclusion is a curious phrase: among other things it is redolent of a kind of "objectification" of what we do in kindness –almost as though if we socially include people, it makes little difference whether we do so in the spirit of kindness. Scruton's point was, I think, that we should spend much more of our time developing our understanding of what it is (and can mean) to act out of kindness rather than "socially including" people on the basis of a political mandate.

↓

241. So I agree with the man who said he did not wish to scrap any words, since they are part of the richness of our language(reflecting the richness of our ways of living) and I agree with Scruton because I think that the phrase "social inclusion" betrays a way of living that can undermine the fundamental importance of what we understand as kindness; what it means to be kind to someone rather than just socially including them.

242. Something similar can be said about the phrase "down time." It is redolent of a kind of

objectification of "having a rest" or "recuperating". Apart from anything else, speaking of rest and recuperation smacks of a form of human fallibility; we get tired and need to recuperate from soul destroying work, for instance. – Though, of course, one might say that "down time" recharges the deficit created by such things. My aim is not so much to criticise the meaning of "down time" but to say that, like "social inclusion", "down time" is indicative of a form of life that draws contrast between it and "resting" and "recuperating."

243. One of the problems in academic intellectual argument is that it tends (for a number of reasons including reductionism and the desire to separate form from content) to allow the distinctive kinds of seriousness that characterize (and are characterized in) certain kinds of problems, to fall away. In other words, in such arguments, the character of the problem becomes estranged from the grounds upon which it was conceived (think about, for example, questions about what art is, questions about what it means to wrong someone (consider this under the light of Consequentialism for instance), what makes something music and so on). When such distance occurs, what is lost is often a dimension of seriousness that puts an idea or argument beyond serious consideration. It is a kind of seriousness that is defined by a particular way of thinking, in which form cannot be separated from content without corrupting the meaning of the thought. When, for instance, I respond to a piece of music or to the meaning of seeing a human being in a state of degradation,

my response and my thoughts about it - the critical concepts I employ- mark that thought as subject to a particular kind of seriousness. They are, as it were, in tune with ways of thinking in which form and content cannot be separated. These ways of thinking carry with them their own expressions; expressions that characterize those forms of thought. To engage in an argument that treats as extraneous the expressions which characterize forms of thought, reducing them to psychological dimensions that can be separated out from the content, intellectually distorts the character of the argument and estranges it from the grounds upon which it was originally conceived; grounds that gave it a distinctive kind of seriousness. Once such separation has been attempted, a dimension of seriousness is lost that could put certain ideas or arguments beyond consideration. That dimension is lost because the style in which something has been presented has been considered as no more than an adornment to the content. Once that way of thinking has been established, there is no good reason to find unthinkable what would have been unthinkable previously; what would have been unthinkable if no attempt had been made to separate style and content. There would be no good reason, because the expression that characterized the form of thought – the full meaning of that thought, with what it called upon us to embrace or reject – has been lost; as such, a dimension of meaning would fall away leaving open possibilities that would (otherwise) have been beyond consideration. Many examples can be found in Consequentialist arguments (the idea that the morality of our actions can be determined

by their consequences). A consequentialist would say that, although it is not very pleasant, we commit no wrong if, in order to save 200 lives, we have to take five; this is so, because overall, the consequences of our actions have been to save more lives than we took and, as such, benefit more people. They seem to forget what it means to take a life, and that, as such, one has still taken five lives and become a killer. So, I think, it is important to retain the kind of seriousness manifest in the character of the problem and the kind of thinking that defines that kind of seriousness. For that reason – to avoid (in argument) estrangement from the grounds upon which such seriousness was originally conceived – it is sometimes necessary to use expressions that characterize forms of thought inherent in such seriousness. What that amounts to is interdependent with the character of the problem and argument. In other words, we sometimes need to use our natural language in such argument.

244. When the character of argument is such that excludes expressions of forms of thought – natural language – that occur naturally in how we react towards one another, it can be said that accepting the legitimacy of such argument is a form of cognitive failure. – Of course, if one tries to mould one's thinking according to the character of such an argument one will estrange oneself from the resources that gives natural language its meaning and importance (sometimes this happens as a consequence of believing that it is unscientific to take seriously, in a quest to see things as they are (wholly dispassionately if you

like), expressions that characterize forms of thought of the kind that one might find in poetry or narrative. But of course, one has to ask whether one sees things as they are if one rejects the terribleness of what is done in murder ("because the thought of terribleness is only an emotion after all; certainly it is not dispassionate. – All that has happened *really* is that one living thing of the species homo sapiens has killed another"). Is that really seeing things as they are?

245. There are plenty of arguments of the consequentialist kind that dismiss certain kinds of expression as irrelevant psychological dimensions that need to be cut away if we are to get at the truth more easily. In other words, such expressions are considered as only adding irrelevant tone that is liable to confuse and mislead; the consequentialist believes that all such tone – of whatever kind – should be cut away to give complete neutrality of description. Examples include: "collateral damage" – a phrase so often used by politicians when speaking about civilian casualties sustained during the war in Iraq and the military campaigns in Afghanistan; "social inclusion" – so often heard from think-tanks which press for rules or policy that objectify what it is to act decently towards each other; "person specification" now so often used when talking about the necessary character a person needs to fulfil a particular role in life; "behaviour modification" – when trying to reform a person's behaviour or attitudes (as if we are automatons), and so on. In each case, in different ways, an attempt has been made to exclude human tone

from the phrase; to cut it out, in an attempt to be objective. Social inclusion need have little to do with kindness (though it need not necessarily exclude it). Collateral damage, it is believed, prevents distracting emotional involvement in war –distraction that might obscure what is really at issue (presumably, a particular goal that involves the killing of a large number of people). And, in any case, what war does not have innocent casualties? Instead of getting bogged down with all that, the thought continues, we need to be objective in our understanding about the war and its consequences.

246. Paranoia/false belief/ruling in and out of consideration/assessment of evidence: madness (or insanity) is not determined by the truth or falsity of one's beliefs. One might believe in astrology, or that one's fate is written in one's hand or in tea leaves; or one might believe that one can stop the incoming tide by sheer force of personality and so on. In each of these cases (and there are many more like them) one might only be considered an eccentric if one held one or more of these beliefs; that in itself however, does not make one insane. Neither does what we might characterise as poor assessment of evidence – we might have taken on one of these beliefs from such a poor assessment. Perhaps one sees certain events in the heavens – such as the coming of a comet – as in some way related to certain events in one's life; maybe the death of a loved one, or that one got that dream job. As such, one assesses it *as* evidence for or against something, drawing

certain conclusions from it.[20] Obviously, there are certain forms of madness in which there is a catastrophic failure of logical thought. Once again however, it needs to be emphasized that perfectly sane people are more or less capable of thinking logically. There are many instances of two sane individuals arguing, and one of them has trouble grasping the logic of the other's argument. (there are many ways in which a failure to think logically can manifest itself – gullibility for instance, or, more generally, opinion.) Yet we do not think that the person who struggles with logic is necessarily insane. So does there become a point when failure to think logically is madness? - Well, there is no actual *point*. Our conception of madness is determined by our thoughts and behaviour as they exist within a community of thought and behaviour. That is what is at work in our understanding of concepts such as madness; within that community of norms, certain things become (or are) beyond our ability to consider seriously. When such things are considered seriously, or when there is no ability to participate

[20] Note that there is not necessarily a failure of logic here – a comet may appear just before the death of a loved one, more than once, so one may then say that one is justified in believing the appearance of comets foretells an event of this kind in one's family. And one need not be deterred from this belief by someone pointing out that, since the comet can be seen by everyone and that since most people have not lost a loved one since its apparition , it must be coincidence that one has lost a loved one each time a comet has appeared. For the person who believes that it is no coincidence could respond: "that maybe so, but it might only affect those who are in a particular astrological relationship with the stars and comets." And so on – there are plenty of other ways such a person could justify calling the apparition of a comet evidence for something.

Philosophical Notes

in any community of norms, that is when we ascribe madness; and when there is no ability to participate in a community of norms of any kind, there is no ability to assess evidence - whether it be that you think illness can be cured by chasing souls into the branches of trees, or treated using antibiotics.[21] (In one sense (wholly individual), what counts as evidence will be entirely arbitrary and no community would accept the "findings" of such an individual). The madness of this kind cannot exist in any community of norms. Paranoia, on the other hand, is marked in a different way: there is false belief, but it is belief that is informed by what we rule in and out of consideration – that we rule the wrong things in and out of consideration. It's almost as if we count the wrong things as evidence or, at least, consider such evidence in the wrong way. What is often striking about someone who is paranoid are the kinds of beliefs they have: "everyone is out to get me!" or, "I can't get a decent job because I was badly behaved at school and have been put on a blacklist that can be viewed by future employers!" and so on. These are beliefs, but in most cases, they are false ones. Yet it is not the content of the

[21] In his famous anthropological work *The Golden Bough* Sir James Frazer observes: 'Some of the Congo tribes believe that when a man is ill, his soul has left his body and is wandering at large. The aid of the sorcerer is then called in to capture the vagrant spirit and restore it to the invalid. Generally, the physician declares that he has successfully chased the soul into the branch of a tree. The whole town thereupon turns out and accompanies the doctor to the tree, where the strongest men are deputed to break off the branch in which the soul of the sick man is supposed to be lodged.' (Frazer, J. *The Golden Bough.* p. 184)

belief that, in essence, makes someone fall into paranoia; it is *how* they think – what leads them to such a belief – that is at the root of their mental illness. How one thinks is interdependent with what we count as evidence; how (or rather, what) experience teaches us, because it does not actually teach us to learn anything from it. We may learn from experience but experience does not teach us what to learn from it (cf. Wittgenstein, L. 'OC' para. 126 onwards). Thus it is, in part, what we learn from experience, how we assess the evidence, that determines how we think about things. For most people, it does not occur to them to think that everyone is out to harm them or that they have been put on a blacklist. That is because of how we think about things; what counts as evidence in terms of how we learn from experience. How we learn logically precedes what we learn. I may see a loving relationship, or a paranoid may see a conspiracy. Ultimately however, it is not that we *ought* to act as we do (to have value, judgment about sanity and insanity in all its forms and so on); it's just that we *do* act and think like this. And our judgement of others as mad or paranoid ultimately rests on the community of norms that establishes the conceptual apparatus through which we can criticise. This way of living grounds certain things beyond doubt for us, which is why we understand someone as mentally ill if he fails to rule certain things from consideration.

247. Time: many times one hears scientists talk about "discovering" more about time, as if we didn't really understand what time was before. Indeed

some say, with tongue in cheek (at least to a degree), that we don't really know what we're talking about when we talk about time – at least that we don't know as much as the scientist. I do not think this makes much sense. To say that we have discovered more about time is to say that we know more about what it is. In fact, what has been done by the scientists is to introduce a new meaning to the word "time", and our concern should be whether such (conceptual) additions to the way we understand time are useful; nothing new has actually been discovered. Scientists have introduced new expressions associated with the word "time" - if they had actually discovered something new about time, it would follow that we could not have understood fully what we were saying when we talked about time prior to such discoveries. As such, we could not have understood properly the meaning of the word. And, of course, if one doesn't know the full meanings of some words, how can one be sure that one is applying them correctly? – But, the scientist my reply: we used the word time in a kind of attenuated sense but in a way which was fully meaningful to us at the time because we knew everything about it that we could know at the time. But that "knowing" is in an attenuated sense – so, on this conception, we can use the word "time" in a way that is fully meaningful, thus getting around the objection that if we don't know the full meaning of the word we cannot be sure we are applying it correctly. The word is fully meaningful, insofar as what we did understand about time went to inform how we used the word; so we could use it perfectly

intelligibly. However, surely then we cannot call what has been discovered "time" because what has informed our understanding of that concept and the intelligible role of the word in our language now only becomes part of the meaning of the word. So how can we call both aspects "time"? Moreover, since we have now "discovered" so much more about time, can we say that when we use the word as we did before such discoveries were made, that we do so in a way that is in ignorance and, as such, run the risk of applying the word incorrectly? Of course not; that is why it does not make much sense to talk about having "discovered" more about time. What scientists have actually done is to introduce new meanings to the word "time" that are applicable in ways closely related to our everyday use of it, but also radically different; ways removed from everyday questions (uses) such as, "what's the time?" or, "why weren't you on time?" and so on. This new way of talking about time that scientists introduced and developed in the 20th century, allows us to better understand many aspects of the mechanics of the universe; but we have not discovered something about time that was previously hidden.

248. The idea that the more aware we become of other cultures and the more knowledge we have of the practices of those cultures, the more we understand about them, is a spurious one. We might accept that treatment for illness by a Congolese medicine man is part of what they might see as medical practice, but we could never seriously entertain the possibility of it *as* medical

practice. Moreover, "medical practice" would not be understood in such a culture, yet it is a phrase we use to describe that practice. This would work in reverse if someone from a culture, such as the one to which the Congolese medicine man belongs, was trying to describe our practices. Our concepts –what is intelligible to us in such respects –are established in our thoughts, customs and practices. We would not find the conceptual apparatus of the Congolese medicine man helpful nor, I think, fully intelligible. (And we could certainly not properly understand poetry associated with such a culture.)

249. The idea that a "knowledge transfer coordinator" can be a vocation (in the old fashioned – proper – sense of the word) is absurd; it can only be a job – one's work. Can one imagine being faithful to one's vocation as a "knowledge transfer coordinator?" The answer to that reveals something of the differences between a vocation and a profession. Following Raimond Gaita, a vocation as I'm invoking it, is something that nourishes one's existence; something one cannot abandon without a sense of betraying oneself (even if, on occasion, that vocation produces evident misery). It is impossible to intelligibly speak of being a "knowledge transfer co-ordinator" in this respect, but one can, I think, speak in this way about being a teacher in the spirit of understanding what it means to provide someone with an education. The expression "knowledge transfer coordinator" does not make it easy to understand what one does under such light. In turn, one then needs a conception of

education –a love of education – as more than a means to an end. There is an interdependence between a conception of education as something wonderful (independent of ends) in itself and teaching as a vocation; as something which one has an obligation to be faithful to. One has no such obligation in a profession though that is not to say that one may not have a sense of obligation to perform whatever job one has to the best of one's ability.

↓

250. Any profession can be given away at any time – if, for instance, one desires a change in career or one retires. One can be a teacher as a profession but it can also be one's vocation and between the two there is no necessary connection. Part of the problem, particularly in the current Anglo-American political climate, is that it is almost impossible to see any external difference between the two – though I'm not sure that it is the case anymore that one's love and obligation towards one's vocation informs or nourishes what counts as professional standards; consider, for instance, the professional standards one needs to be a "knowledge transfer coordinator." And, I would suggest, that because there is a trend towards believing that truth can only come out of external justification, external difference is more and more what we're coming to rely on.

↓

251. I said earlier that the importance of being a teacher, in terms of understanding what one was

doing by providing someone with an education, would mean that the thought that one needs to somehow glamorize the profession by calling teachers "knowledge transfer coordinators" was absurd – unthinkable. At what point did such an idea become thinkable – that is, something that could become seriously considered?

↓

252. I'm not saying that those for whom teaching is not a vocation cannot be good teachers, but I am saying that there is a fundamental difference in how they view what they are doing – it is a view nourished by the spirit in which they teach. That difference can, I think, be understood by reflecting on what one is doing for one's students by teaching them. For a teaching vocation to properly be a vocation it needs to be in the light of the thought of what it means to be a teacher in terms of giving an education; education understood as mediated by an unconditional love of the world and a passion for understanding, free from any ideas of it as a means to an end. If what I say seems hopelessly ideological or out of touch with reality, then it is because of estrangement from those things that make it possible to see as intelligible, the idea that one can have a love of truth without any other purpose. In this light –the light of estrangement from those things – the concept of a vocation can never mean much more than a (non-academic) job gained through "vocational qualifications." Countryside management is thought of as a vocational qualification, as is, for example, tree surgery or

someone in animal care. (but why, now, is medicine not seen as a vocational qualification or, for that matter, a teaching degree?)

↓

253. Much of this – of seeing education as something to be cherished for its own sake without any other purpose – relies on one possessing a perspective (with all the dimensions of the thinkable and unthinkable that that entails) that sees life as wonderful; as something which furnishes one with so many – perhaps infinite – possibilities. Someone who sees life in such a light will feel some sense of obligation to teach others in the same spirit and show them what that means. Those that do not, will only have their teaching defined by professional standards even if they feel that they should do the best job they are capable of. Professional standards are necessarily defined by the culture of their time (or the spirit of their age). It follows, therefore, that they are subject to the pressures of their time. A profession need have nothing to do with a sense of obligation brought through the belief that life furnishes us with infinite possibilities, and of the thought that we should be faithful to the possibilities that we realise. Indeed, it would probably consider such thoughts as psychological distractions from being professional in a clinical objective way (or however "professional" is defined).

↓

254. An activity associated with a vocation is fundamental to who someone is. Someone who

sees their life as wonderful, often looks upon it in the spirit of gratitude. Someone who cherishes education, cherishes the possibilities it yields, will find themselves with an almost overwhelming number of interests (perhaps interest is the wrong word here – love may be better) they feel compelled to be faithful to. They will not feel that it is an effort to acquire general knowledge (or feel a sense that they ought to). – It will be a natural consequence of their gratitude (though its strengths may reflect what they love). Viewed in this light, it is likely that life will be thought of as something that can be snatched away at any moment.

↓

255. Someone therefore, who only possesses a commonplace conception of what life can bring - only has a love of say money and/or just getting a job for the sake of it, will only have a limited conception of its possibilities and will be unable to live in a spirit of gratitude for his life (that is not to say that he won't enjoy it or wake every day gratified by his bank balance and the thought of making more money and what he can buy with it.).

↓

256. In other words: someone who only loves those things will be unable to cherish an education – what it can do to a life by enriching it beyond measure –and, through that, they will become an example of what that is. That is not to say that such a person cannot be happy, nor is it to say that

they cannot say they have had a great life and mean it. But it does mean that they might consider education as worth very little if it made them no money (or was not a means to make money). – In gratitude one is in supplication to the possibilities that a human life possesses. That is why Socrates said that an unexamined life is unworthy of a human being; it is a life that does not recognise what a human life is capable of – the possibilities it brings. (why ignore such possibilities?)

↓

257. A life lived in the spirit of gratitude (that one is lucky enough to be blessed with such possibilities – I am invoking nothing religious here) need not be a life free of suffering or even (necessarily) a happy life. Sometimes, one's obligations to one's vocations will make happiness difficult – if, for example, unresolved conflict exists; when that happens there is sometimes the danger that there will be meaning collapse, where one loses the capacity to be moved in ways that reveal life's possibilities and what gives life sense and meaning. But that need not happen if one accepts that possibility as a form of potential misfortune (like succumbing to mental illness).

↓

258. (If what you believe life offers you is commonplace, then as a person, you will reflect that; you will become that person, vulnerable to the assessment that you are commonplace). You will become like the possibilities you see that life holds – that is what gives us the ability to talk of a reflective life, an

unreflective life, or an unexamined life and so on. Someone who is unreflective, believing that to philosophically examine one's life is just navel gazing – a waste of time when one could do something much more productive – would only be able to measure his life in terms of bad, okay, fun, good, excellent (or on some such scale) depending on whether he had achieved the goals he set out for his life or whatever. For someone who lives life in the spirit of gratitude, there can be no such scale; and because one is living in such a way, one is compelled to be faithful to its possibilities and to live truthfully in accordance with them and their demands.

↓

259. From either side as it were, one will encounter people to whom one has nothing to say, not because one dislikes them or is contemptuous of them or anything like that, but because the possibility of authentic conversation demands that one is able to take certain things seriously. It will be difficult, for example, for someone whose primary aim in life is making money or, perhaps, someone who is dazzled by (and sometimes envious of, though not necessarily bitter, if they don't have it) money and its trappings, to find their feet with someone's vocation whether or not it makes them money. One can imagine a simple conversation of this kind:

X: "So what is it that you do?"

Y: "I'm a Doctor. – I specialise in general practice – I've wanted to practice medicine from an early age"

X: Wow! That must be megabucks!"

..... and so on.

↓

260. So, I do not mean that there is literally nothing that two such people can say to each other (and I am assuming that the doctor entered medicine because he wished to devote his life to healing the sick – (I am sure that not all doctors enter medical practice in this spirit however, it may well be that some do so with an eye to the financial rewards.) For my purposes however, their vocation is to heal). I mean that the possibility of serious conversation at such a level (about why, for instance, the doctor took it upon himself to devote his life to healing the sick) requires a conception of living which *can* put such thoughts above all else; in a way that would not call for remarks such as: "well, everyone has their preference" or, perhaps, more condescendingly if the doctor was giving of his services voluntarily, "Well, I suppose he knows what he's doing" (the latter is less likely; nonetheless I have heard it uttered in a similar context, though not in connection with a doctor) or, perhaps: "Still, the money must be very useful." etc.[22]

↓

[22] The emphasis placed on certain things in conversation, such as life and money, often reveals how we think about them; someone may say that it is good not to think of money as the be all and end all in life , yet the kind of prominence it has in their remarks and conversations shows, that for them, it is perhaps more so than they claim directly.

261. Put another way: it is about taking such a way of living without a shred of incredulity (or disbelief: "surely he can't really think that!?" etc..) And, of course, one can put the whole thing round the other way: "How can the orientation of your thoughts revolve around that kind of materialism?" etc..

↓

262. So, conversation is possible but not in a way that allows for attention to the subtleties and serious considerations of a life nourished by a vocation. It is difficult to conceive of a life centred on money, or concern for those who have it, to be talked about in such terms. Do we consider such a way of living to be as rich in meaning as a life devoted to teaching, healing, history, understanding what it means to wrong someone and so on? I am not wanting to prosecute people who desire to make money or gain prestige, but I am criticising the idea that one's life should be judged as more or less successful or more or less commendable based on such criteria.

↓

263. An education needs, at its core, to maintain a certain resistance to external cultural pressures of its age. By that, I do not mean that it should not pay attention to the culture in which it is embedded, nor am I saying that what comprises an education should not be influenced by cultural times; for otherwise such education would be incomplete. But it is to say that one should treat

the values, beliefs (and what counts as properly relating to those beliefs in the culture of the time), and how we think about things in the culture, in a way that does not treat them – automatically at least – as superior to any other ways of thinking that might nourish different values and beliefs (and what counts as rightly relating to such beliefs). That will ensure that one is given the space that allows one to come into contact with such values and beliefs in a way that makes it possible to soberly assess them, rather than treat them as, say, anachronisms or the products of "traditions" or "social norms."[23] There are two aspects of our present culture that can be used as examples in this respect. The first is the - perhaps conspicuous – widespread use of targets in many aspects of our culture (education is an area where they feature heavily). The second, and related aspect, is the desire to separate form from content, which is derived from the belief that one always needs to do so in order to get at the truth, which may otherwise be obscured by psychological dimensions in our expressions. The aim, therefore, is to create a neutrality of description, the content of which is not vulnerable to psychological distortion (examples of this presently)

↓

264. Let us then look to the education system for elucidation of the first aspect. There are many

[23] Often, when such values and beliefs are treated as anachronisms or traditions or social norms, their authority to speak to us with the same force that they once held – or with the force that our current values now hold – is compromised.

complaints (often from teachers) that the education system is too target orientated, and that there is too much testing. Many say that obsession with mandatory targets has led to compromising on quality in order to achieve what has been legislated by the government. State schools are particularly vulnerable in this respect, since they are much more answerable to the national curriculum and the legislation laid down by the government of the day as to how the education system should be structured, and the form in which education should be "administered." Much of this is thought of as something that marks the present culture in the UK. I think that is right. What is less clear is what is wrong with such an approach. – For surely one needs to have targets in order to be able to assess standards with a degree of accuracy and reliability? And, furthermore, the argument may continue, the setting of such targets need in no way entail that education is bowing to the pressures of cultural times; that its standards are being influenced by present cultural norms. It's just a way of measuring standards to ensure continuing improvement. – Granted, it may be that there is an issue in terms of getting the balance right between target achievement for exam results (the number of exams that teachers need to prepare their pupils for; the time spent by teachers filling in the various assessment forms and so on) and enough time to teach in a way that does not just train for exams. Yet there are questions here - the first and most obvious being: how do we determine what the correct balance is? – Surely, that in itself is entirely arbitrary and is, perhaps, conditioned by

the culture of the time. The kind of education provided by a curriculum answerable to government legislation will necessarily reflect the culture of the times, because such a balance will be dictated by legislation devised in that particular era. Thus, in this respect, it is not immediately clear how any approach governed by "getting the balance right" can be resistant to the culture of the times. Yet, there are arguments that could be made which might assert that there is no other way in which the system can work effectively, and which might further suggest that there is no reason, in principle, that prevents us from soberly assessing values and beliefs in a way that does not allow the fact that they are understood (in current culture) as traditions or anachronisms to compromise our thinking about them. But how can such thinking address the education system itself and be free of such prejudice? For surely, it will be impossible to assess, even by results, other forms of education, if there exists a presupposition that current practice is considered best – even if there is still the issue of "getting the balance right"? Why can't one assess such things using results? Because the culture, with its particular target focused system, will yield results derived from that way of doing things; it is current conditions that determine the methods by which we acquire the results. One cannot, therefore, use such results, because they will show up nothing other than an individual's ability within the system in which he is working. One might be pressed to think about issues of balance by examining similar education systems (European and American for instance) and how these

compare against our own; but that is a different matter.

↓

265. It might seem then, as though this way of looking at the problem backs us into a corner, insofar as there is no way we can look upon our own way of doing things, wholly dispassionately. What I have said might seem all very well in theory, but what else can we do other than pursue a course that is most effective in our way of living; that is, one that prepares us in a way that is in tune with the culture of our times? So, in this respect at least, a target driven education system of whatever balance is necessarily subject to the cultural pressures of its times; dependent, perhaps, upon cultural goals. But are our cultural goals always well advised? – Are they necessarily better than anything that has gone before? Does the evolution of the culture and its goals necessarily mean progress (as seems to be often thought)? – An education system subject to, and geared towards, preparing us in a way that is in tune with the culture of our times, will only yield results that perpetuate that culture, rather than one that constructively criticises it. – That is not to say that there would (or could) be no criticism of a culture whose education was geared towards preparing its students in ways in tune with it; but it is to say that such criticism would be of a kind that merely encouraged embellishment (and furtherance) of the practices of that culture, rather than being fundamentally critical of it. (Often such criticisms are dressed up as "radical" when really they are

not). The culture of the time provides the platform for such criticism rather than the platform itself being examined. (How can we tell from what point of view we are examining culture? How can we tell if we are using the platform or not?)

↓

266. The second aspect is the desire to always separate form from content, based on the belief that it is the only way to get at the truth (this is particularly prevalent in our own times). Truth is, as it were, tied wholly to facts in this respect. – Forms of expression, the many ways in which we express things, are, it is thought, just psychological dimensions of our lives. Thus, the thought goes, we have cognitive (factual) content that can be justified independently of any human being, and non-cognitive (various forms of psychological) content that often manifests itself in the *ways* we express things. One might make comments or criticisms about someone else's remarks by saying that they put the (their) point "dramatically" or in a way that is more psychologically appealing, making one more inclined (a psychological fault) to take it seriously (despite having no further reason to do so). It is a way of exploiting our vulnerability to psychological distortion (one often encounters it in the arguments of politicians, for instance, who say things in a certain way, in an attempt to get us to accept their arguments). The idea is then, that in order to get at the truth, one needs to separate the manner in which such remarks, comments and statements are made, from the content of what they are expressing.

However, although this is necessary in some cases, it is essential that it is not done in others; it depends on the character and nature of the thought and its content. There are, for example, poems, pieces of music, works of art, that express things that cannot be expressed in any other way; the form that they take is internal to the content of the expressions and, as such, their meaning.[24] Sometimes they are necessary for a deepened conceptual content – of religion, for example. Yet, there are also times when truthfulness is distorted by psychological response; when for example, a scientist allows his method of experiment to be influenced by his desire for a particular outcome. So, how are we to look at this in terms of education? There are times when our conceptual content relies on authoritative examples. Such examples might include wondering at someone's compassion for another; such compassion often brings others to see more about the object of their compassion, as well as admiration for the compassionate person. In other words, their example illustrates something. Once again, expressions of compassion are not contingently attached to something we call compassion that can be established independently of the expression. But what makes such an example authoritative? - Surely we can say that those who are compassionate are sometimes wrong; that their

[24] If one shouts in anger or says. "I'm angry", one's expression is not a non-cognitive response that can be separated from one's anger. It is that shouting which expresses anger – it is not contingently attached to something we call anger that can be verified independently of the expression.

examples are not authoritative? What criteria can be used to determine authoritative from non-authoritative examples? Indeed, what is it that allows us to see certain kinds of actions as illustrating something (or, indeed, anything) about the object at which such actions are directed (or in response to)? – Finally, such examples are only shown up as authoritative through examples of what they are not; that is, examples that we take as counterfeit, perhaps corrupted by one's vulnerability to nostalgia, for instance. One can have authoritative compassion and sentimental compassion. These things – what allows us to see differences between authentic compassion and sentimental compassion, for instance –are determined by our interacting responses towards one another, and the meaning that we find in such responses. It is this that conditions *how* we think about others, establishing the concepts we use in such thinking. It is, therefore, to say that some kinds of truthfulness are only shown up in authoritative examples, but that that truthfulness is not something that everyone need grasp –or is able to grasp – in the same way. Some, for instance, might be persuaded of the authenticity of a form of compassion; others may not. Whether we determine those that are persuaded as sentimental or properly responsive, and whether we determine those who are not as cynical or properly responsive relies on how our interacting responses have conditioned our understanding of examples as authoritative or counterfeit.

↓

Philosophical Notes

267. Some, for instance, might think that if one looks after livestock for slaughter, it is impossible for such a person to care for such animals with the same degree of love, respect and tenderness as someone who finds it morally impossible to slaughter animals or eat meat. Only when one has encountered an example of someone who looks after livestock and loves them deeply but is prepared to send them to slaughter (i.e. that one considers it as such an example), can one be brought to the belief that it might not be so; and that very much depends on the witness. My point is not to have a discussion of this kind (here), but to suggest that certain forms of truth rely on forms of thought in which cognitive and non-cognitive content cannot be separated because it makes no sense to separate them; because the kind of thought that it is, means that it's quite arbitrary as to where we might draw the line between cognitive and non-cognitive content. Put another way, there are some kinds of thought where there is no such thing as cognitive and non-cognitive content; there is just the meaning of the thought, and the expression that accompanies it.

↓

268. When one encounters thought that cannot be expressed in any other way other than in a poem, piece of music, work of art for instance, one encounters dimensions of our thinking that can deepen much of our conceptual content, showing, through infinite examples, what it can mean to love, what it can mean for someone to lose everything that gives their life meaning and

dignity, what it means for someone in this condition to have fallen on such times, and how that can be shown up by compassionate response and so on. Such thoughts and ideas can be expressed in poetry, music, works of literature, and other ways that cannot be made lucid by ordinary language. (why else is it that people write poems about such things?)

↓

269. Many of these forms of thought condition and nourish our understanding of their subject; a poem that declares one person's love for another, or the wonder we sometimes encounter in response to the natural world, reveals something of its subject matter in terms of meaning; the meaning they can have for us.(It is a meaning that cannot be measured)

↓

270. It is, as such, in a particular kind of way, a dimension of our reality. Just as it is non-cognitive (psychological/emotive) content that can distort our understanding, making us victims of nostalgia or anthropomorphism (for instance), as in the case of a scientist who allows such things to overwhelm his ability to construct an experiment that will yield impartial results, so it is a psychological response that can make us believe that we need to rid ourselves of forms of thought characterized in poetry, art, music etc., if we wish to understand things more clearly; if we wish to understand our place in the world with other people and animals more clearly, for example. It

is, so to speak, a psychological response in relation to science (but separate from it). That is to say, it is a psychological response that makes us believe that we always need to separate form from content (non-cognitive from cognitive content) to get at the truth. And the psychological dimensions of such responses are found in expressions that condescend to the treatment of poetry, art and music, as fundamental to understanding what it means to be human (and, as such, what it means for a human being or animal to suffer degradation, for instance). They are also found in expressions that claim to transcribe the full meaning of a poem in neutral description; someone might say for instance: "oh, that poem just means this...(insert neutral description)." Often, one hears talk about "mushy stuff" or "all that stuff is very nice but it doesn't help get at what is really at issue" and so on. The idea being that to be a hard-headed truth getter, one needs to abandon the "mushy, airy-fairy stuff." But that kind of response is as much of a psychological (non-cognitive) response as is the response of the scientist who allows his anthropomorphism to influence the construction of his experiments. In other words, it is a psychological, non-cognitive, response that has caused the failure of clear thought; one that interferes with our capacity to see things as they are. Some say that we should take our cultural achievements less seriously as, at bottom, we are just animals: that is also a psychological response in relation to science, that acts as an impediment to clear thought. Although some scientists might hold the view that we take the cultural aspects of our lives too seriously (poetry, music, art, theatre,

opera and so on), it is a view based on a psychological/emotive response to scientific practice, and has little to do with science as such; it is a psychological (personal) response generated by (impersonal) scientific practice, and is not a necessary consequence of science or scientific endeavour. There are some, both in the humanities and sciences, who believe, for example, that morality is nowhere near as complex as some people believe it to be. They will say that, ultimately, all morality and what is termed "moral response" can be collapsed into the idea that we do it to serve our own ends (individually and as a species), whether that be to actually get something out of it, or just make ourselves feel better. That is because little of what finds its expression in, for example, forms of art, counts for them in ways that (they think ought to) nourish understanding of what it means to be a human being, what it means to wrong another person, or the natural world, and so on. And it is because the possibility of clear thought has been impeded by a non-cognitive response, that such thinkers are unable (or unwilling) to attribute importance to forms of thought that admit of no external justification (justification beyond the human). Consequently, some people have been led to the false belief that all moral response is ultimately self serving or, at the very least, species serving. This is an example of non-cognitive response *causing* a thought's failure.

↓

271. So what is the relationship between this and education, and what it means to possess a fine education? This is a complex question and involves examining the relationships between how our concepts are nourished and enriched by authoritative examples, how that conditions what we find thinkable and unthinkable, and how seeing the world in a certain light – how the world is cast in one's formative education –conditions what we see *as* authoritative examples. There is a great deal of interdependence between these factors in terms of the relationships between them that, I think, can never be exhaustive; as such, for my purposes in answering this question, it would be no help trying to list as many as possible. Rather, I want to try to show how the relationships work, how the ways one sees certain examples as authoritative or not, relies on in what light the world is cast for one, how that may reveal or dissolve contradiction, and how our conceptual landscape is shaped by such things.

↓

272. For a moment, I want to return (for illustrative purposes) to the idea that morality is ultimately species serving and that, as such, we should see actions that we call moral, in such a light. - Perhaps that is so, but it seems impossible to say with any authority beyond speculative conjecture. And it certainly does not follow that we should treat morality, and those things to which we appeal for moral lucidity, in reductionist form. Yet, it is that thought which tends to manifest itself in response (a psychological non-cognitive

response) to authentic scientific thought; it is a psychological response to legitimate scientific progress, and one that causes us to approach, in reductionist fashion, dimensions of our lives where no good reason has been given to do so. In other words, just as the person who craves a certain outcome will allow his investigation to be tarnished by such desires, so the person who believes that morality is solely related to our species' success will find himself looking for ways to reduce it down to certain principles. But it need not be that way: even if a person believes that the ethical dimensions of our lives are ultimately species serving, it does not follow that morality needs to be reduced down to certain principles. Why not see it as part of what conditions our understanding of one another? - In other words, as a part of our epistemological faculty. One could then say that the ways we understand each other in the light of the moral dimensions of our lives, are a part of the way our species has evolved to survive and continue to survive. Then there becomes no need to try to reduce these aspects of human life to certain principles. (Incidentally, I do not, myself, believe that morality is ultimately species serving, but for reasons that are not relevant here.)

↓

273. My real concern here is to talk about education, and my point has been to try to highlight certain dimensions of our lives that cannot be measured, and that cannot be justified by reason alone. Certain examples become authoritative because

they strike us in a certain way; we see the world (our perspective) in a way in which such an example *is* authoritative – that speaks to us in an authoritative way; a way that is defined as authoritative through its capacity to deepen our understanding of what it reveals about its subject. – I don't want to be interpreted as talking about role models. Sometimes, a particular person will, through word or deed, reveal something, perhaps about themselves, or about the subject/object of their words or deeds. The trouble is that they are frequently then taken to be a role model, even though the example they have set – or what they have revealed through example – involves only a particular aspect of their lives. This puts intolerable pressure on them in terms of the burden of expectation of others, who now view them (or believe them to be) role models. Such "role models" will almost never be able to rise to such expectation, nor should there be any obligation for them to do so. Why should they be expected to give authoritative examples in all aspects of their lives, just because they have done so in one? – Certain sportsmen and women spring to mind – they evince a love of what they do, and show what that can mean to someone; they become examples of what one can become through dedication, hard work, and a love of what they do. Yet, if they are involved in, for instance, bad behaviour, they are criticised for that behaviour often far beyond what would be justified by such behaviour. Some will say that they should recognise that they are viewed as role models by others and therefore take extra care. But that is precisely the point: the idea of the role

model is dangerous because it asks more of people than they are generally able to provide. Thus it needs to be understood that authoritative examples can come from anyone, but that it does not mean that they should be looked upon as able to reveal things in other aspects of their lives in anything like the same way. That, of course, is not to say that there are not people who can do this; who provide authoritative examples in many aspects of their lives – they are rare however.

↓

274. And I have not meant to limit my talk of authoritative examples to human beings. For although human beings reveal the most wonderful and terrible things – consider a wondrous compassion towards someone in suffering, that shows what it means to have fallen into that condition or (on the terrible side) someone who tries to take away the dignity of another through degrading and exploiting everything that they hold dear.[25] Yet wonderful things reveal themselves elsewhere: in the natural world; its beauty, the music, poetry and art that can express the meaning of such revelation (and in human instances too – the poetry of love and compassion, for instance). One should not be uncritical of course, and the danger is that I'll be thought of as hopelessly ideological (as just a bit of a hippie perhaps). But an appreciation of such things, and the efforts made to develop it, provides meaning and

[25] That 'terrible example' is also an example that shows up the meaning of what is done.

understanding of a kind found less and less in conventional education, and of a kind that cannot be nourished by more targets and exams or shorter holidays. That is because such things cannot be measured, and are, as such, not answerable to statistics. There are two things to be said here: 1. Through the trend towards believing (conditioned by nothing more than psychological response) that the manner in which something is expressed should always be separated from the content in order to get at the truth, we have estranged ourselves from the ability to take seriously, as part of a human education, those aspects of our lives that are not answerable to target and statistics. 2. An education should not be only about preparing people for a way of living that exists already (though of course, it must be about that as well) – for the culture of the times as it were. It should be about nourishing and developing all forms of understanding, and providing others with a love of the world necessary to develop their own. It is about developing a love of living and an understanding of the possibilities that a human life can bring.

↓

275. No balance between teaching and targets (or whatever) can get that right, though it seems to be believed in current Anglo-American culture that it can. That, I think, is because such a belief is in service to a psychological response (or non-cognitive response) of a similar kind to that of someone who believes in a reductionist ethics based on the idea that morality is species serving

(one could say the same thing about education). In other words, it is a response in service to the idea that education (and its standards) needs (and has) to be measured. But this fails to realise that understanding what it means to possess a good education and how that is assessed, need not (*not "should not"*) rely on an external quantifiability – that is, quantifiability answerable to assessment. One of the reasons that more and more emphasis is put on targets and externally assessable achievements (and importance accorded to them), is because we have a desire (a non-cognitive psychological desire) to measure our standards of education in a way that can be externally justified, eliminating the need for individual judgment. It then follows that what cannot be treated in such a way should be considered less relevant –perhaps as something that should be learnt *about* rather than as something which can nourish forms of understanding and reveal something meaningful. Another reason is that there is a tendency to measure education in terms of career success or, rather, see education as a means to that success. In other words, see it as a form of training or a "set of skills" necessary to bring about certain outcomes. That, again, is a form of psychological response but different in kind, insofar as the importance of a career, or money, or prestige, is thought to be directly answerable to such things. These ways of thinking *cause* a failure of proper thought and understanding in terms of what education is or can be.

↓

276. When ideas of this kind become established in a culture, what is thinkable and unthinkable will reflect that. As such, things that were previously unthinkable will become thinkable and vice versa. Lessons, or instruction, in morality at school become perfectly plausible, and the thought that one of the most important aspects of any education is what it means to have a love of something, becomes something nonessential.

↓

277. Lessons in morality assume that it can be taught in a similar way to English literature, geography, history, geology and so on (and I'm certainly not saying that one should not have targets, assessments, and examinations in relation to *these* subjects). We are told, for example, that it is wrong to treat people with condescension, or racially or sexually discriminate and so on. We uphold these things on the back of "evidence" – that we are all rational creatures with thoughts, feelings, projects and desires, and we know what it feels like to be discriminated against. None of that establishes the meaning of what we do when we wrong someone, and it is not something that can be taught in that fashion. The world needs to be cast in a certain light in one's formative years, so it is natural for us not to discriminate in terms of race or gender, and natural for us not to condescend to those struck down by misfortune. It is not possible to assess how the world is cast, but it has become unthinkable that education (and what it means to possess it) can be properly achieved without targets and assessments.

Understanding what a human life can mean and the possibilities that a human life can have seem to have become little more than a distraction from: education > job (career) > money > retirement. Add to that, prestige (how you are seen in the eyes of others) and that's pretty much it. Of course these things are important and I am not suggesting that they should be shunned or that those who perceive their life in such a fashion should be thought of as shallow or not living fulfilled lives. But I am suggesting that we should see education as something precious, to be cherished; something that is far more than an investment – wonderful, irrespective of career or money - in terms of one's career and/or money. It is more than knowledge transfer; it is something that can make life wonderful; and education can be more than passionate interest – it can be a love of one subject matter (whether it be astronomy, meteorology, a love of people, music, literature, physics, biochemistry &c) that reveals to others what the world can mean. That is an authoritative example – something that can educate.

278. Language analogies: some people say things like, "oh, he's well into his wildlife!" or "he's well into his shopping!" And people also treat them as just preferences – which, of course, they are. I prefer watching butterflies, writing music or looking at the heavens, to searching for a new pair of trousers for example. Or, one might say, "I don't like looking at wildlife or going round museums!" And the thought, therefore, becomes that we should treat all these things in similar ways; as likes and dislikes (which, of course, they are). But

would we say the same thing about a philanthropist or humanitarian? Would we say (without absurdity): "He's into humans like I'm into shopping!" Or: "He's really into his humans!"? – One does not, somehow, feel comfortable with that.(what if one does feel comfortable with it?) The reason is that language can only be language if it is nourished by what is meaningful. Thus, it reflects, as well as being a part of (the two are interdependent), our ways of living. Language – the practice of language – expresses (among other things) how we are able to reflect on something as meaningful and, because of that, we are able to publicly reflect on and criticise, the differences and similarities between things.[26] The reason, then, why we feel uncomfortable, is because there is something slightly absurd about saying that someone is "into his humans" – the way it is put is synonymous with the way we say that someone is into his gadgets, trains or stamp collecting. The meaning of philanthropy (not the meaning of the word, but the meaning of what it means to practice philanthropy) is very different from the meaning of the practice of stamp collecting or shopping or being into gadgets and so on. The absurdity and discomfort stems from treating as synonymous in language, what it means to be a shopper or a stamp collector etc., and what it means to be a humanitarian. – And that meaning stems from what can be revealed to us by other human beings; in the most general terms, we can understand what

[26] We use concepts to assess these things, and concepts are necessarily public (cf. Wittgenstein's Private Language argument)

it means to have fallen into a condition in which one has lost everything that gives life dignity and meaning, and we can understand what it means to dedicate one's life to helping such people. I draw the contrast between the humanitarian and the shopper or stamp collector to provide a sharp illustration in terms of the sort of thing I want to talk about. A difference of a similar kind exists between: "He's really into natural history!" and "He's really into his shopping!" though it does not show anywhere near as dramatically, and that is directly to do with its subject matter. Because we can share our lives fully with other humans (the way others move us *demands* attention) the difference in terms of meaning (conceptual content) and the demands that it makes upon us in terms of the seriousness with which we take other human beings, means that the linguistic differences – the differences in meaning – show up more dramatically (Though it does not necessarily follow that someone will see any absurdity in saying that a humanitarian is "into humans" – that might particularly be so if they are racist and the humanitarian is involved in work to assist those that are the focus of such racism. Or it might be because they suffer from a form of autism)

↓

279. Because the natural world (for instance) does not reveal itself with the same kind of meaning and, frequently, with less immediate revelatory power – and because this is a part of our thinking and practices – the differences and similarities (in

terms of subject matter) that provides the grammar for the absurdity that is apparent in the assertion about the humanitarian ("he's into people, I'm into shopping. Each to his own!") are less obvious. They lead one to think that an interest in the natural world is the same as an interest in stamp collecting, shopping, train-spotting and so on. But can one say that one has a disinterested love of these things in the same way as one might have a disinterested love of the natural world or of nature? Can one have a sense of obligation towards shopping in the same way one can towards the natural world and the creatures that inhabit it, and are a part of it? Is it even possible to have a disinterested love of shopping, stamp collecting or train-spotting? The fact that it is not (the fact that it is absurd to say that one has a disinterested love of stamp collecting) *is* part of the conceptual difference between a love of nature and love of stamp collecting. Or, better put, it is part of the (possible) conceptual difference between them in terms of what it means to love them, or what they can mean and what they can reveal. That is part of what conditions our understanding of difference in subject matter and why we should not just treat a disinterested love of the natural world as a preference in the way we would treat a preference for shopping over stamp collecting, for example. (That there are these differences is what nourishes talk – for good or ill – of shallowness in those who might say that such interests are all of the same kind).

↓

280. I have no wish to prosecute any of the interests I have been discussing here, since they are all dimensions and possibilities that comprise the richness of human life. But I am trying to show that there is a danger of a kind of 'meaning collapse' if all these things are considered as just preferences. One needs to understand the differences and similarities if one is to understand the nature of either properly. One needs to understand the difference between unwinding by pursuing a hobby such a stamp collecting, shopping, train-spotting, playing on the PlayStation and so on, and reacquainting oneself with –to borrow Raimond Gaita's is phrase – our creatureliness as an aspect of humanity and the lives of other creatures.

281. "New innovation" is a tautology; "Fresh innovation" is (somehow) logically close to that, and "another innovation" is logically distinct. "Fresh innovation" could be "another innovation" or tautologous. It seems somehow ambiguous – rather close to a tautology but with the possibility of there not being a tautology. – That is what I mean by logically close, yet it is not clear what logically close is without a language we understand and understanding what it is to belong to a language. By saying that "fresh innovation" is logically close (though not necessarily equivalent) to "new innovation" I am expressing an idea (that one thing is close to another). Language is an aspect of our ways of living that is a practice much like any other, but it is also a practice that is radically different from any other. It reflects and makes public what we think, how we think, the

form that our thoughts take and, above all, it is meaningful; it does not always say something about a subject – sometimes it is the expression *of* something. If it were not meaningful, then it would not be a language –it would merely be a series of noises (perhaps we can analyse those noises in various kinds of sound machines – but that would not make it language). In other words, if the signs and gestures that comprise language were not understood as bearing any relation to other signs and gestures (this holds for whether you understand the language or not) and were not seen or understood as meaningful, then such signs and gestures would not be language. The grammar (what gives sense and meaning), therefore, that allows us to perceive a logical closeness (a kind of relation) between "new innovation" and "fresh innovation" (for example) is established in our practices and how we think about them. (We might live in a way in which every invention was never treated as innovative. In such a case, it would make no sense to try to logically distinguish between "new innovation" and "fresh innovation." There would be no way anything could be logically distinguished; there would be nothing to distinguish.)

↓

282. Yet, "fresh innovation" could also be seen as close to, or equivalent to, "another innovation." In this case it would depend on understanding what was meant by "fresh innovation" correctly – understanding the idea as it is expressed in

language and, as such, understanding whether the phrase was tautologous or not.

283. Logic can be used within any way of living – ways of living of which language is a part – but logic doesn't exist prior to language; it is not logic that gives rise to language. Language is not answerable to pure logic; it is answerable to what is meaningful within a form of life and, of course, we constantly use logic in our various ways of living. A language answerable wholly to logic – a logically pure language – could not possibly (logically) be understood as a language. All of it (in order to be internally consistent) would need a vocabulary in which there existed a word for absolutely every object. Thus one would have "simple" words for "simple" – absolutely basic – objects (how this would look (or work) I'm not sure) and compound words, such as mountain, father, proper nouns, sea, mist, symphony, art and so on that would all be words constructed out of simple objects (words that only refer to simple objects).[27] The problem is, that were I to refer to a mountain or Scotland or the sea etc., then, for my language to be internally consistent, I would have to ensure that each compound word always took the same simple objects (words) each time it was employed. If I changed the constituent parts (simple objects) of a compound word (even slightly) then this would need to be specified. Yet

[27] I cannot think of anything that would count as a wholly simple object. – We might say that compound words such as "mountain" or "Scotland" comprise things such as height and geographical location respectively, but neither of these words is simple either; they are compounds of other compounds.

the biggest and insurmountable problem – one that makes it impossible to ensure that such a language is internally consistent – is that the "simple" objects I use for compound words might very well be different from those that others use. In other words, the constituent parts – the fundamentally singular, basic simple objects - that I use for my understanding of the words, father, Scotland, art and so on, may be different; and we have no way of discerning, in speech (when we employ compound words), whether the constituent parts we use in our own case are the same as those of others. In other words, the criteria for the application of each compound word would be essentially private to the individual using them. Without having agreed criteria (and I'm not sure how that could be done without identifying every possible simple object), it would be impossible for one person to independently establish whether he was applying his own criteria correctly in each case. Thus logic does not come prior to language. Rather, our sense of meaning in language relies on the role(s) that a word plays (that aspect of meaning) in a way of living; logic can be applied in a language (to show how it would be reasonable to proceed, for example) but it can't be applied to language. And where do we look, in terms of simple objects, when it comes to love, wonder, art, goodness, fear, anger and so on? All of these words perform particular roles in terms of meaning but they don't have constitutive parts; their meaning is defined by the meaningful roles they play in our lives.

284. Art expresses forms of thought (in which form and content cannot be separated) in ways that cannot be put into any other form without corrupting meaning. As such, it expresses our ideas in a way ordinary language cannot. I'm not saying that it can express ideas that are totally beyond the reach of ordinary language, only that ordinary language is unable to fully express what the art does in a way that doesn't compromise meaning in some sense. As such, one can learn from it in a way that one cannot in ordinary language (and vice versa). Some art is more profound than other art; that that is so, and can be recognised as such, is because it belongs to a life with languages and meaningful expressions that others participate in. In all forms of art there can be trivial, banal treatments of an idea, and there can be deep, wonderful treatments.

↓

285. In a panel question and answer session to mark the release of the film of Raimond Gaita's book, 'Romulus My Father', Gaita is asked: "was the truth [of the book] preserved in the transition from novel to film?" Gaita's answer is that he's not sure how it is, but that it is. He also says that it is the art of the director to take factual basis and make of it something different but importantly true to the spirit of the book; there is hardly a scene that depicts something that actually happened.

↓

286. There are some films that do not do this; some, that stick wholly to what happens in the book they represent, fail completely to remain true to the spirit of that book (as such, they lack an important dimension of truth). The film of 'Romulus My Father' is, I think, rightly thought of as a work of art because it is what the film does to the spirit of the book; it nourishes that spirit rather than just representing ideas that is has taken from the book; as such, it nourishes our sense of meaning. That is how it remains true to the book without detailing every event as it is in the book – it is not an illustration of the book. Of course, there are films that capture the spirit of the book they represent and, largely accurately, depict events (though I've never seen one that does this completely and I'm not sure it's possible). The Merchant Ivory production of Kazuro Ishiguro's novel 'Remains of The Day' is a good example. We can see clearly a relationship between art and how we understand; it relates to the way forms of thought are expressed, and that enables us to distinguish depth from shallowness, seriousness from triviality and so on. The film 'Romulus My Father' can be said to be an artistic development of the book through its nourishing our understanding of themes in the book. *That* is how the truth is preserved in the transition from novel to film in this particular case. In other cases that does not happen, or it happens differently. There are similar relationships in other kinds of art. Vaughan Williams' piece of music 'The Lark Ascending' nourishes and contributes to forms of thought expressed in George Meredith's poem of

the same name. It is a response that is much more than a musical illustration, if its ideas are grasped (otherwise, why would one respond to it any differently than one does to the poem?).

↓

287. These different kinds of responses – Gaita's treatment of his childhood and of his father's humanity, Richard Roxborough's treatment of the book in his film, George Meredith's poetic response to the song of the skylark, Vaughan Williams' response to that poem and so on, - belong to a way of living (with all that is thinkable and unthinkable in it). One can split art down into components – the painter can look at technical aspects of a painting, the musician can examine a work for theoretical integrity and, as it were, reassemble it in a way that shows it as a breakdown (there are various forms of complex analytical techniques used, such as Schenkerian Analysis in addition to basic music theory). None of these, however make the art or music what it is; our understanding them does not make something art or music; they do not make music meaningful or show us why it is so (why there is meaning).[28] All of these forms of analysis only exist on credit from what they analyse, so to speak, because none of them would be seen as artistic or musical analysis without there being something understood as art or music that existed prior to their formation as disciplines. In other words, they would not exist without there being something

[28] They are, of course, very useful in other ways.

meaningful prior to any kind of analysis. In an important sense, they tell us nothing about art or music. (That is why it is mistaken to think that classical music, for example, can only be wonderful to those who have an interest in it, or know something about it. The same goes for poetry and other kinds of literature, as well as for paintings.)

288. Art also nourishes perspective through its contribution to conceptual content. It is an aspect of a way of living that can enrich many of the concepts we encounter; for art expresses forms of thought associated with many of our beliefs and practices, and these expressions can serve to nourish such concepts within a culture. Some ideas that art expresses are more difficult (perhaps more serious) than others; they demand much from the observer. If the observer sees nothing in them – fails to see how they contribute to an idea (Fauré contributing to the meaning of a requiem, for instance) – their understanding of its meaning will remain unnourished in that way. But music, like all art, need not 'treat' a theme as such, but it can, nonetheless deepen our understanding of an idea. Consider, for example, music that nourishes our ideas in a film or advertisement. It adds meaning and can (though not necessarily) deepen our understanding of what is expressed in the film or advert. Sometimes, of course, it adds nothing, and that is what allows us to criticise it as banal or "nothing music."

↓

289. And one encounters those who neglect forms of art because such forms do not resonate with them; sometimes that is because they are unwilling to take the trouble to engage with anything that isn't "easy"; that doesn't gratify immediately. Sometimes it is because the arts treat an idea that exists beyond their conceptual domain (that is, what even counts as a concept for them); as such, it will be unintelligible to them and not considered as art.[29] In cases where it does exist within their conceptual domain and they do not see (or hear) anything but a "nice sound" in music, for instance, their conceptual content will remain unchanged, nourished only by what others can tell them about it. Such people are generally those who see art as a bit pointless (although they may still like popular forms of it for instance – particularly in music).

↓

290. I have no wish to prosecute popular art of any kind – for it too, expresses forms of thought that, often, cannot be put any other way. However, I do wish to prosecute an unwillingness to put any effort into engaging with other forms that demand more effort and attention. Such unwillingness will leave a much thinner conceptual content; thinner because one is cut off from the possibilities that such forms of art nourish. It is a vicious circle, because one is unable to judge properly from a standpoint of ignorance, but one is also likely not

[29] One might consider some of the controversial conceptual art created by artists such as Tracey Emin and Damien Hirst.

to see any worth in such forms and, as such, criticise it in that way. That is not to say that we have to like all art –some we may think is poor. But we can often express such an opinion from a vantage point nourished by our grasp of an idea and the artist's treatment of it. Because art contributes to our conceptual content (through its meaningfulness), it also contributes to the life of a culture. A culture in which, for instance, classical music is seen as no longer relevant to the modern age, will have lost a particular dimension in terms of its ability to make of joy, death, tragedy and love what it does in a way that only classical music can. Similarly, if such music is treated as elitist, or as something 'quite nice', or as something in which one must have an interest if one wishes to appear more cultured than others (having been to many concerts I can testify that this latter point seems to be quite prevalent), then such music, in its many different forms, will not make anything of sadness, joy, tragedy and love in the way it could if listened to honestly without any other purpose. Those apt to sneer at popular music (again, apologies for the generic term) again deny themselves the deepened and enriched conceptual content that it can bring. For all kinds of music can bring something to joy and tragedy, love, despair or enmity. It is the nature of the beast that some requires more effort than others; yet once it is there, it can enrich our lives beyond measure.

↓

291. That is why we can (justly) accuse those who dismiss art as unimportant, as small minded, with only a mediocre conception of life's possibilities.

292. In a film, all sorts of music can nourish our ideas (meaning) in all sorts of ways. That is why films often need music and why they would be flat without it. There are, however, exceptions (that almost prove the rule, so to speak) such as the film "The China Syndrome" which has no music at all. But that does not mean that all films *could* be produced without music. Or rather, if they were, then they would lack what music would bring to them. Vaughan Williams' "Fantasia On A Theme by Thomas Tallis" is often said to represent a particular idea of England – that is, it lends that idea a dimension that would be absent otherwise and, as such, gives the concept greater depth. It could be used in a film that way, but, nevertheless, it does not tell one anything about England. That is a dimension that such music could bring to a film, which could not be done in any other way. In different ways, art and poetry can do the same things (expressing forms of thought in which form and content cannot be separated and that nourish meaning and conceptual content). Of course, Vaughan Williams' music can only be understood in such a way from someone steeped in the culture of which it is a part.[30]

[30] That does not mean that those immediately outside that culture will never be able to love it as passionately as those within it (that would only be the case if it was actually about something that could not be understood from outside the culture) though they will not perceive it in the same light.

293. Nevertheless, an aspect of being a part of a culture, is being a part of a community in which one understands the ways things are expressed; the ways things are expressed reflect the life to which those expressions belong. – It is necessary that this is so for the expressions to make sense (for them to be intelligible as *meaningful* expressions). Though of course, we can recognise certain practices in other cultures as expressions – though not grasp their proper significance – through understanding the role that similar practices have in our own culture (that they are expressions); and the similarity comes from their relationship with language and the kind of meaning – and conceptual content – that language makes possible within a culture. Language expresses certain kinds of meaning that have various kinds of relationships with the various kinds of art; - that is how art exists in a relationship with language; how we can talk about it *as* meaningful. For otherwise we could not articulate anything about art, and, if we could not do that, it follows that there would be nothing meaningful in the practices we call art, nor any reason to pursue them.[31]

294. That art expresses forms of thought in which form and content cannot be separated, nourishing our conceptual content, thus contributes to what we find thinkable and unthinkable; and it is through the meanings of the forms of thought such

[31] Strange that I have to be so careful to say what I mean in the right way. What is the right way? - The way that is given in language by using it in the correct way.

expressions represent, the understanding they foster, that provide the grounds for why people make music, write poetry and create art at all. The difficulties, joys, hatred, suffering, our mortality – those concepts and many others – we encounter in our lives, are all nourished by the arts. How often do we appeal to the arts for lucidity in times of joy, grief and suffering? Indeed, the arts in their many forms often express such things that cannot be put in any other ways. As such, they are a part of the language of such concepts, part of what we understand as nourishing the content of those concepts. To deny art a place in one's grammatical vocabulary – to deny its relevance – is to impoverish and starve one's sense of meaning.

295. I might find something wonderful in music – or in a concert – but that does not mean it *tells* me something. It might just nourish my sense of wonder and what is wonderful. It might just *be* wonderful.

296. There are, of course, times when the music that accompanies a film may not nourish the concepts which the film invokes, or at least not nourish them in a way that is appropriate; it may not nourish the topics that the film takes on, or is about, in a way that is well founded. A film – its subject matter – may cut to the deepest possibilities in our lives, and it may do so seriously and without pretence. There are many serious films about genocide, torture, love, hatred, our mortality, grief and bereavement, for instance – yet the music may be of a kind that tries to

exploit our emotions (or it might be of a kind that adds nothing). And we might then be tempted to say that its reason for being there is to illegitimately persuade – to evoke feelings for a situation that, somehow, are not properly in keeping with the relationships portrayed (and the kinds of seriousness that such relationships ought to invoke). But does it succeed? – That very much depends on the person judging. It does not mean that such music will always leave one with a misunderstanding – for we possess the critical concepts to understand that serious ideas have been corrupted by guile. And, in any case, if such music always left us with misunderstandings, it would be extremely difficult for us ever to perceive them as misunderstandings. Nevertheless, some will be persuaded, perhaps because they have a disposition that way – perhaps they are nostalgic, for instance. Yet the fact that we possess such concepts is testament to our ability to determine when we have been legitimately and illegitimately moved. And *that* – our ability to distinguish between art that nourishes and art that corrupts –shows that we should not always consider art as the non-cognitive dimension of our thought; it is something that is necessary for meaning – for the content of concepts and how we use them – that is shown up in our ability to make such distinctions between corrupt and genuine. Finally, the ways in which art can corrupt are only shown up by examples of when art can nourish, and that is determined by our interacting responses that give rise to many of the critical concepts we use in our understanding of others, and which supply us with

an awareness of such differences and examples. It is our interacting responses that provide the concepts we use in our criticisms (good or bad) of different examples. Of course, films don't require any music in order to be sentimental, banal, cynical; the way they treat love, death, hatred and mortality can determine that. My point here has been to say that we are able to distinguish between times when form and content should and should not be separated, and that that capacity is a dimension of our critical and epistemological faculties. It is a kind of critical thinking that is often overlooked.

297. There is the thought that morality or ethical responsibility should be developed through principles or values. I would suggest that this is the wrong way round (though "values" is logically closer to what I have in mind). An ethical awareness surely develops through an awareness of the meanings of one's actions that is conditioned by a regard for the relationship one has with the subject matter. And that meaning, I think, is revealed by how the world is cast for one in one's formative years and, later on, by one's relationships with others. In other words, moral education is nourished by meaning that is revealed through one's perspective; that perspective is seeing the world in a certain light (and conditions what we find thinkable and what we should put beyond consideration) through which meaning is revealed. It is no good just saying: "these are the principles we should adopt!" Or, "these are the values we should have!" because none of that strengthens our

understanding of the meaning of what we think or do. When confronted by a situation with moral dimensions we do not think "I need to abide by these values or principles in order to do the right thing!" – One might express moral certainty by saying: "I had to do that! He's a human being! What else could I have done? " or, if we lacked certainty, we may agonise over what we should do – how we should think –but that agony is not resolved by a lack of knowing which principles we should apply. If it was, the agony (if one could sensibly call it agony) would be of the same kind as when we are not sure whether we have used the correct formula in response to a mathematical problem, for instance. The idea of *mattering* in these two respects is very different in character and in kind. And we may find a moral necessity after agonising, or we may not, but neither is because we have either succeeded or failed in applying the correct principles. We do not need any principles for ethical awareness.

298. In connection with ideas expressed in art: as in all walks of life, some ideas are generally more easy or difficult to grasp, as is shown up by the majority of people who find such ideas more or less difficult. But, in one's general education, it is not thought to be a good excuse to say: "I am not going to make any effort here because this idea is too difficult!", "I do not like algebra because it is too difficult!" or "I'm not going to bother with algebra because I don't see the point of it!" and so on. And one might say the same thing with many other disciplines.

↓

299. But because the ideas expressed in (and by) art are of a different kind and character – because, for one, they are not tangible insofar as there is nothing external to which they can be pinned – there is a tendency not to try to engage oneself with those forms that one doesn't, instantly, find a kind of affinity with. The difference between popular and classical music (to use those words too broadly) is one such area. Often, but not always, the forms of thought characterized by the former are easier to grasp than the latter (and vice versa); but that is not to say that one shouldn't dedicate part of one's life to trying, for one might succeed and then one's conceptual landscape will be all the richer. Then again, one may not succeed, and there is no shame in this (though some who "appreciate" art for the wrong reasons might think so – those people who like to "be seen" at concerts or the opera, for instance).

300. When I use the word "idea" in relation to art, I am not using it in the sense of having an idea about something (for instance, how to fix the computer) – that is, something definite (although, in some cases, I'm saying it can nourish an idea). I am using "idea" to describe a form of thought – one that can only be expressed in a way in which form and content cannot be separated without corrupting meaning. The reason I use "idea" is because such forms of thought - if they are to be intelligible (even seen as forms of thought) – need to relate , somehow, to our conceptual landscape. If there was no relationship at all, then there

would be nothing intelligible; nothing to understand. One would be unable to talk about such an idea because there would be no idea – nothing that related (in any way – sensibly or absurdly for instance) to anything else. That does not mean that an idea needs to be about something, but it may nourish an appreciation of something, bringing a new kind of understanding.

301. This is how the relationship between art and artist is understood. Art is a form of intelligible expression, though that does not preclude the possibility that certain forms of it are not understood by certain people; those people may not consider such forms to be art or they may call it art only by virtue of their recognition that it plays a certain role within a culture. The latter recognition is, as it were, on credit from the recognition that it plays a particular role. As a form of expression it is not necessarily about something; nevertheless, it is a form of thought that is manifest in that expression. Of course, when it is not *about* something there can be no separation between form and content (there is a definite kind of logical exclusion here). However, even if the art is a treatment of a particular idea – if it contributes to that idea (such as William Byrd's four part mass contributing to the idea of the Eucharist) then it need not be any more sensible to attempt to separate form from content, without compromising meaning. Nonetheless, if the art is bad, one may be able to extract form from content. A poor piece of art whether a poem or painting, for instance, may just be construed as a description of something that has been dressed

up – that then becomes a criticism of art (one could not perform such separation with music because music can never be dressed up description[32] – that is one of the many aspects that distinguishes music from other art forms; that does not mean that music cannot sentimentalize an idea for instance).

↓

302. When a work of art contributes to an idea there is an important sense in which it is not *about* that idea – it is not describing something that is already there, but (rather) contributing to something that can be described in the future (with the inclusion, in some way or other, of what the art has added to it). There is a logical exclusion here too, but the exclusion relies on something different: In the case where the art is not contributing to any widely recognised idea such as religion, there is no possibility of its being a description – thus there is no possibility of separating form from content. In this latter case, the logical exclusion revolves around whether the art is understood as nourishing the idea, or merely being dressed up description.

↓

303. I do not want to be understood as saying that in cases where art (as expression of form of thought) does not nourish an idea, that it does not relate to an aspect of life; it needs to be intelligible which

[32] We could hear the music with no knowledge of what it accompanies and not see it as a dressed up description of anything.

means that it must relate in some sense(s) to other things that are meaningful. In other words, it needs to be a part of a particular way of living; but that in no way entails that it needs to be about (or nourish) certain ideas in that culture that are established already. It can give rise to new ideas - and several simultaneously, depending on the differences in 'understanding' of its audience. Other works of art can then nourish those ideas (that is one way in which a culture can deepen itself and evolve).

304. Art that does not directly nourish another idea(s) still has to relate to the culture that has given rise to it for it to be intelligible. It needs to relate to other things that are meaningful, even if it is the development of a thought or a new idea. Often such art is an expression of an artist coming to a particular kind of understanding (think poetry in particular here); his response to a particular way of living. What the audience understands from the art will, therefore, be quite different from that of the artist, because the response is essentially different in kind. The artist's response is nourished by what has brought him to express himself in that way; his audience are responding to his expression.

↓

305. And, of course, different art is capable and incapable of expressing different things. A piece of music cannot be a description elaborately dressed up, but a poem can be; nevertheless, both can contribute to something that can be described

in the future, and both can be described as sentimental, banal, or authentic. In those ways and many others, different kinds of art are related. Similarly, most (if not all) art has "popular" and "classical" forms – both of these contain the possibilities of depth and shallowness. But what is the relationship between i) different kinds of art (why do we see them as art?) and ii) different forms of the same art e.g. classical music, jazz, rock, heavy metal, techno, trance and so on?

I. If one asks: what is art? One might as well ask: what is language? The answers to these questions are often sought by taking examples that people agree on as art, discussing them in a way that tries to ascertain a series of necessary and sufficient conditions, and arriving at a definition. That no one has managed this is no accident. Frequently, similar methods are employed when trying to distinguish between different forms of the same art – for instance, jazz, classical and rock music.

II. We see different kinds of art as music, poetry, sculpture, painting and so on, by virtue of them being kinds of expression that are meaningful in the same way as language is language by virtue of it playing a meaningful role in a way of living. – One doesn't call anything that's carved, a sculpture (for instance), neither do we necessarily call the creation of noise, music. And although music and sculpture may exhibit breath-taking skill, it is not that which makes it art either; skill need not express anything at all. If skill was what made art art, then anything skilful would be art – or, rather, we would have no grounds to

distinguish between something that is just skilful and something that is art. The grammar that allows the possibility of such a distinction would not exist.

↓

306. The relationship between different kinds of art is what allows us to see both music and sculpture as art. Such relationships are not defined by the activity - for what is the relationship between carving something (for instance) and making particular noises? Making music is not just assembling notes, which is why musical analysis would not exist without there being something meaningful prior to such analysis. Musical analysis – as with other forms of art analysis – does not make something music, or whatever art it is. The relationships that allow us to understand sculpture, poetry and music as art, are defined through the forms of their meaningfulness – to both artist and audience. Jazz expresses forms of thought different to classical, and different forms of jazz and classical music are related to one another through the forms of thought that they express. That is how we understand Dixieland and Bebop as forms of jazz, or why we consider Vaughan William's 'Fantasia on a Theme by Thomas Tallis' and Bach's Brandenburg concertos as classical; or why we consider music by The Beatles and Radiohead as forms of rock, and so on. The recognition of the different kinds of art, as expressions of forms of thought that can only be expressed in those ways without corrupting meaning, *is* the relationship that allows

us to say that sculpture, poetry or music are all forms of art.

307. One frequently encounters criticism of art in which the critic speaks of "energetic lines" (a number of explanatory plaques in the Tate Modern say this and similar things). One is tempted to ask: what makes such lines "energetic"? – And one might be given an explanation about the techniques used (bold brush strokes, dynamic use of colour and so on). Yet none of that – and this is a different but closely related question – explains why such lines are energetic and, in relation to that, what makes them so. – One might say that such lines are analogous to other things we understand as energetic (certain animate things, for instance. But can one explain the analogy?). Rather, I think, such lines contribute to one's understanding of "energetic"; they are not descriptions of "energetic" – they are part of what we understand *as* energetic in a similar way to how shouting at someone can be an expression of anger (the shouting is not a description; it conditions our understanding of the concept of anger). For in one's explanation of an analogy, one runs into the question of why the things we make the analogy with are (also) energetic.[33]

↓

308. How we understand such things is at the root of how we understand others.

[33] All these ways of living contribute to the concept of "energetic".

309. Some people may repeat the same activity over the course of a lifetime. Sometimes this can draw consternation from others –they may say: "you've been there already many times! Why on earth would you want to go again?" Or, they may say: "why don't you play something else now? – You always play that!" I am not talking merely about routine - though, of course, such a way of living would count under such a conception. I am speaking about an activity that mediates a love of the world and conditions a perspective from which one feels a sense of gratitude for one's life. I'm not talking about a gift in a way that has it given from someone to someone else (so I'm not talking about gratitude to God). I am talking about a form of gratitude – gratitude for the wonder and possibilities that a human life makes possible. And the spirit of that gratitude can be nourished by repeating activities that count as philanthropy or returning each year to visit particular natural wonders, or to listen to, or play, the same pieces of music, to read the same book and so on. These things can reawaken that gratitude and need never become tired. Each time can be like (doing it for) the very first time, but not in a way in which one marvels at something new; it is one's gratitude that can make one feel that way, and one's gratitude that provides one with the obligations to do it. Of course, there are certain activities that are necessarily excluded from the kind of repetition I am talking about. One may have an addiction, or one may experience a form of therapy from shopping, stamp collecting or train-spotting for instance, which may cause one to repeat such

activities over and over again. But it is the kinds of possibilities inherent in such activities – what they can reveal in terms of meaning - that makes them different from the kinds of activity I am discussing here. In other words, we can distinguish between these things through a critical awareness of the meaning they can give to a life.

310. Of course, an interest in natural history can be of the same kind as an interest in shopping or stamp collecting, train-spotting and so on; and I am not, for one moment, suggesting that certain interests are somehow better than others, or that they should be shunned in favour of something else. It is a disinterested love of the natural world that can reveal forms of meaning that a purely contingent interest cannot. An interest in nature need not rule out the possibility that one doesn't like certain creatures or plants (for example), or that one is repulsed by them. That is not a possibility with a disinterested love; one has a sense of obligation towards all creatures (though its character and form may vary and need not rule out culling, for instance), and it means there is the possibility of betrayal, cruelty and so on, that can never be present in stamp collecting or shopping. That is part of how we distinguish between these things in terms of the meaning they can have. One's love of the natural world might have developed through working on the land as a labourer or farmer, or it may be a form born from an interest in conservation, but it need be neither of these things. What I am saying is that a disinterested love of the natural world can nourish meaning – it can show what it means to be cruel or malicious

towards our own kind and other animals and, through that, provide moral necessity and impossibility in equal measure. And that in turn, can nourish the spirit and sense of gratitude for one's life (though this is by no means a corollary)

311. Attempts to make things faster and faster are often incompatible with aspects of life which demand time in order to be fully understood. In each age, people think that what went before was often insufferably slow; I thought my computer was quite fast two years ago, but in comparison with the latest models it is now frustratingly slow; sometimes, I feel that I need a new one in order to manage. This is how things have gone on since the dawn of human progression (for recent examples, look at the industrial revolution and the general mechanisation of industry). The problem is, I think, that we have recently reached a time when a desire for the shortening of the times things take, is resulting in absurdity. When this happens, it is because judgment has been completely ignored, which is why we see the absurdity at all. Consider, for instance, the development of (new) multi million pound rail links that only shave a few minutes off final journey times. However, it is within the domains of art and ethics that the indiscriminate desire for things to happen ever more quickly can inflict the greatest damage. Frequently however, such damage goes unnoticed, or the cause of it is attributed to something else. When it is attributed to something else, it is often the case that that something else is also a product (or casualty) of a desire for ever increasing speed. For our desire

and attainment of greater speed (devoid of the judgment as to where it is appropriate to apply it) results in a change in how we think about things, which is answerable to the bond we have with our environment that is conditioned and fed by kinds of understanding born through how we respond to it.

↓

312. Some forms of understanding – notably those present in the arts and ethics – necessarily take time to achieve; understanding, for instance, what it means to wrong someone (not just that doing something *is* wrong). And, through our forms of thought, art will reflect, nourish and contribute to our ideas and understanding relating to such things.

↓

313. If our understanding becomes impoverished through a failure to take time over such things, the forms of thought that give rise to artistic expressions will change also; the ways we express our selves will be different. Indeed, much well known modern art of the last 15 years or so often seems to be aggressive and that, I think, is interdependent with (or symptomatic of) much modern attitude; attitude that is conditioned by our ways of thinking.

↓

314. Of course, our understanding of ethical matters can be impoverished in many other ways too – each of these ways has a distinctive character. The

way understanding is impoverished by a lack of time also has a distinctive character (perhaps that is best expressed through art).

315. Time will always be short in a culture in which the dominating component is a permanent need for greater speed. It takes away the time one needs to look at things thoroughly, and the time one needs for them to show what they can mean. If one lets such things pass, then the ways such things are understood and the forms of thought that are derived from such understanding will be different – "thinner." It is a question of taking the time to "see." One can be aware of something and not "see" it, and the more one is concerned by the need for speed, the less one will notice – the less one will "see." "Seeing" as I mean it here, isn't the same thing as being aware of something's existence.

316. The difference between (only) being aware of something and "seeing" it, as I have tried to show, fundamentally affects how we understand things. It nourishes our understanding of similarities and differences between things, providing the grounds upon which we can distinguish art from (just) skill for example.(The grammar that allows the possibility of such (logical) distinctions, so often resides in the distinctions created by the difference between (only) being aware of something and "seeing" it).

REFERENCES / BIBLIOGRAPHY

Where [....] I have used acronyms.

Cooper, D. *Meaning.* Acumen. Chesham. 2003

Cowley, C. *"That was the biggest mistake of my life." Some Problems with evaluating momentous decisions.* (Unpublished Manuscript)

Diamond, C. ['HML'] 'How Many Legs?' in *Value and Understanding: Essays for Peter Winch* ed. Gaita, R. Routledge. London. 1990.

Diamond, C. 'Rules: Looking in The Right Place' in P. Winch and D.Z. Phillips (ed.) *Wittgenstein: Attention to Particulars*. London: Macmillan. 1989

Frazer, J. *The Golden Bough.* Wordsworth Publishing Ltd. Ware. Hertfordshire. 1993.

Furrow. D. *Against Theory – Continental and Analytic Challenges in Moral Philosophy.* Routledge. New York. 1995.

Gaita, R. A *Common Humanity.* Routledge. London. 2000.

Gaita, R. 'Ethical Individuality' in *Value and Understanding: Essays for Peter Winch* ed. Gaita, R. Routledge. London. 1990.

Gaita. R. *Good and Evil: An Absolute Conception.* 1991. Macmillan. Second edition Routledge. Oxford. 2004.

Gaita. R, *The Philosopher's Dog.* Routledge. London. 2003.

Grayling. A.C. & Weiss. B. 'Frege, Russell, and Wittgenstein' in *Philosophy 2 – further through the subject*. Ed. Grayling. A. C. Oxford. OUP. 1998.

Honderich. T. (ed.)*The Oxford Companion to Philosophy.* Oxford. OUP. 1995.

Hudson.W. D. *Modern Moral Philosophy*. 2nd edition. Macmillan. Basingstoke & London. 1983.

Hutto. D. D. *Wittgenstein and the End of Philosophy – Neither Theory Nor Therapy*. Palgrave Macmillan. Basingstoke. 2003.

Joyce, J. 'The Dead' in *Dubliners*. Penguin Modern Classics (new edition). London. 2000.

Kant, I. *Grounding for the Metaphysics of Morals*. (Trans) Ellington, J.W. Hackett Publishing Company. Indianapolis / Cambridge. 1993.

Kierkegaard. S. *Journals and Papers vol.1 A-E.* ed. and trans. Hong. H.V. and E.H. Indiana University Press. Bloomington and London. 1967.

Kierkegaard. S. [Johannes Climacus]. *Concluding Unscientific Postscript*, trans. Swenson. D.F and Lowrie.W. Princeton University Press. Princeton. 1941.

Kierkegaard. S. *The Point of View,* trans. Lowrie. W. OUP. Oxford. 1939.

Lippitt. J. *Kierkegaard and Fear and Trembling.* Routledge. London. 2003.

Malcolm, N. *Ludwig Wittgenstein:* A Memoir. OUP. P75 Oxford. 1958.

McDowell, J. *Mind, Value and Reality*. Harvard UP. 1998.

McGinn. M. *Wittgenstein and the Philosophical Investigations*. Routledge. London. 1997

McNaughton. D. *Moral Vision – An Introduction to Ethics*. OUP. Oxford. 1988.

Mill. J.S. *Utilitarianism*.1861. (ed) Crisp. R. OUP. Oxford. 1997.

Monk. R. *Ludwig Wittgenstein: The Duty of Genius*. [TDOG] Vintage. London. 1991

Nagel. T. 'Kant's Test'. in *Equality and Partiality*. OUP. New York. 1991.

Nagel. T. *The View From Nowhere*. OUP. New York. 1986.

Nagel. T. 'What is it Like to be a Bat?' in *Mortal Questions*. CUP. Cambridge. 1979.

Nussbaum. M. 'Introduction: Form and Content, Philosophy and Literature' in *Love's Knowledge*. OUP. Oxford. 1990.

Plato. *Gorgias*. trans. Hamilton, R. Penguin. London. 1971.

Plato. *Laches*. trans. Lane, T. edit. Saunders, T. Penguin. London. 1987.

Priest. S. (ed.) *Jean-Paul Sartre: Basic Writings*. Routledge. London. 2001.

Rhees, R. 'Art and Philosophy' in *Without Answers*. Routledge and Kegan Paul Ltd. London. 1969.

Rhees, R. 'Religion and Language' in *Without Answers*. Routledge and Kegan Paul Ltd. London. 1969.

Rhees, R. 'Responsibility to Society' in *Without Answers*. Routledge and Kegan Paul Ltd. London. 1969.

Rhees, R. 'What are Moral Statements like?' in *Without Answers*. Routledge and Kegan Paul Ltd. London. 1969.

Sartre. J.P. *Existentialism and Humanism*. Methuen Publishing Ltd. London. 1948.

Singer, P. ['PE'] *Practical Ethics*. Cambridge University Press. Cambridge. 1993.

Solomon. R.C. *The Joy of Philosophy – Thinking Thin versus the Passionate Life*. OUP. New York. 1999.

Stenlund, S. 'Ethics, Philosophy and Language in' *Commonality and Particularity in Ethics*. Ed., Alanen, L., Heinamaa, S. and Wallgren, T. MacMillan. London. 1997.

Stroll. A. *Wittgenstein*. One World publishing. Oxford. 2002.

Von der Ruhr, M. 'Kant and The Language of Reason' in *Commonality and Particularity in Ethics*. Ed., Alanen, L., Heinamaa, S. and Wallgren, T. MacMillan. London. 1997.

Weil, S. ['IL'] 'The Iliad or The Poem of Force' in *Simone Weil: An Anthology*. Penguin Classics. London. 2005

Wiggins, D. *Needs, Values, Truth*. OUP Clarendon Press. Oxford. (Third edition) 1998.

Williams, B. *Ethics and the Limits of Philosophy*. Fontana. London. 1985.

Williams, B. *Moral Luck*. Cambridge University Press. Cambridge. 1981.

Winch. P. 'Moral Integrity' in *Ethics and Action – Studies in Ethics and the Philosophy of Religion.* Routledge & Kegan Paul Ltd. London. 1972.

Winch. P. 'The Universalizability of Moral Judgements' in *Ethics and Action – Studies in Ethics and the Philosophy of Religion.* Routledge & Kegan Paul Ltd. London. 1972.

Winch. P. 'Wittgenstein's Treatment of Will' in *Ethics and Action – Studies in Ethics and the Philosophy of Religion..* Routledge & Kegan Paul Ltd. London. 1972.

Wittgenstein. L. 'Ethics, Life and Faith'. in *The Wittgenstein Reader.* (ed.) Kenny. A.. Blackwell. Oxford. 1994.

Wittgenstein. L. *Philosophical Investigations.* 1953. Blackwell Publishing Ltd. Third edition. Oxford. 2001.

Wittgenstein. L. *On Certainty.* Edited and translated Anscombe. G.E.M. and von Wright. G. H. Blackwell. Oxford. 1969.

Wittgenstein. L. 'The Big Typescript'. Translated Kenny. A. in *The Wittgenstein Reader*. Blackwell. Oxford. 1994/

Wittgenstein. L. Tractatus Logico-Philosophicus. 1922. Routledge Classics edition. London. 2001.

Wittgenstein. L. *Zettel..* Edited Anscombe. G.E.M. and von Wright. G. H. Translated Anscombe. G.E.M. Blackwell. Oxford. 1967.